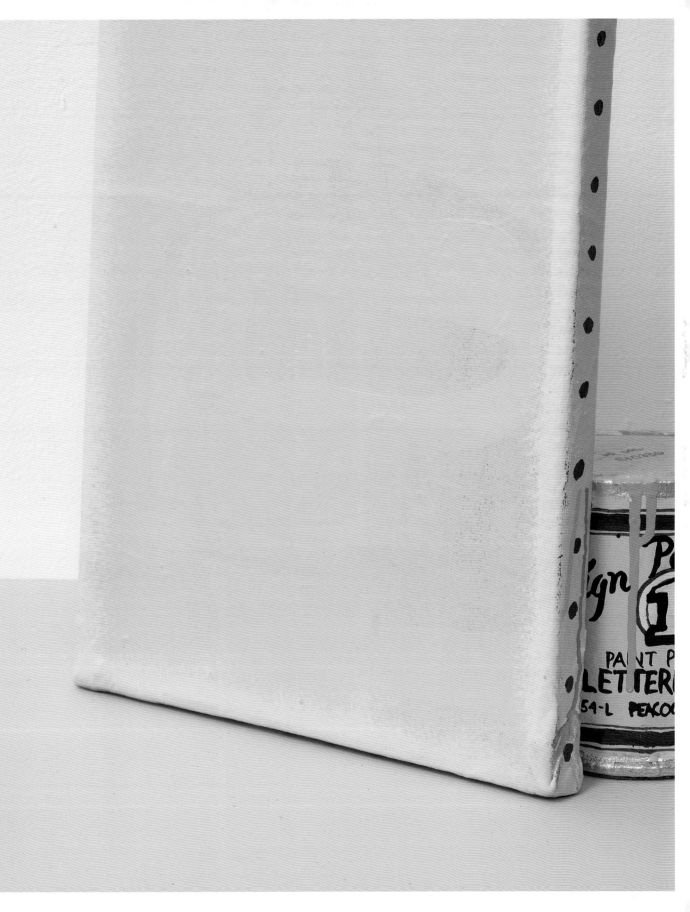

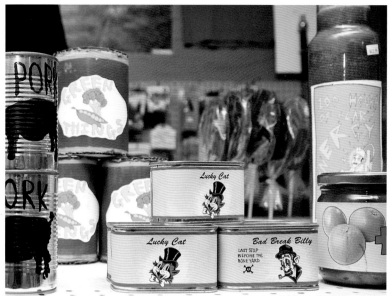

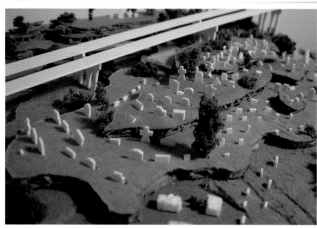

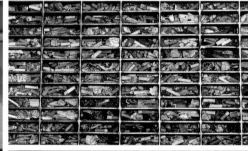

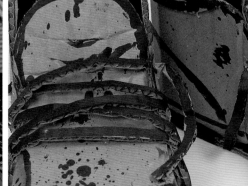

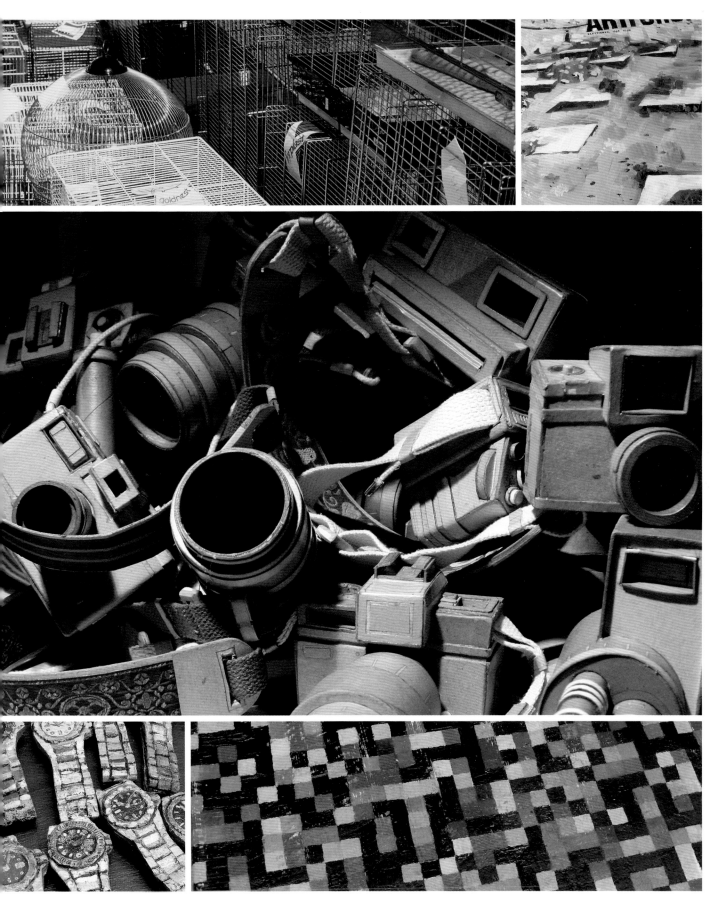

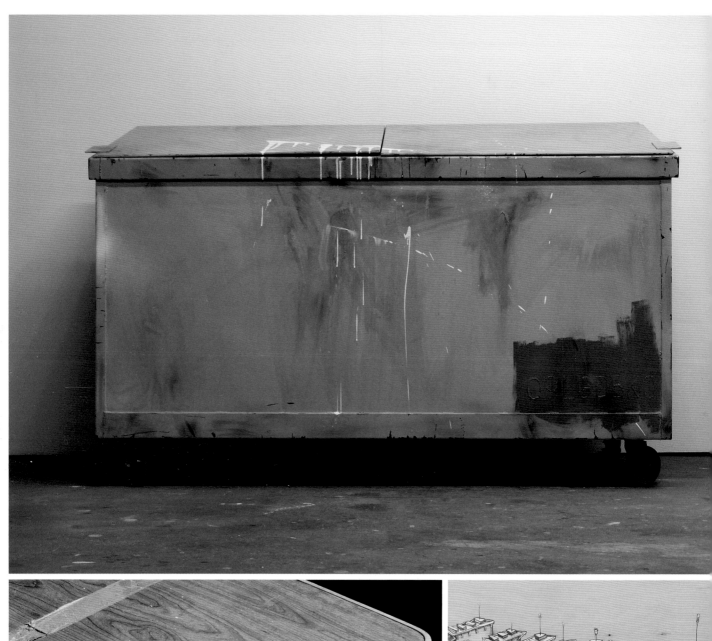

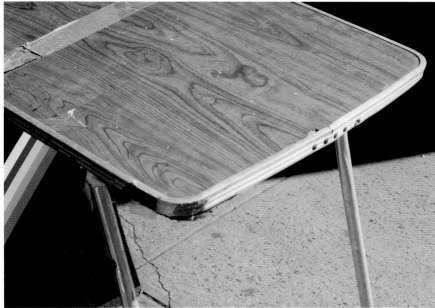

[page 1]
Tom Burckhardt
Peacock (detail) 2007
Enamel on cardboard, wood, and Variform, 15 × 13 × 6 in.
Courtesy of the artist

[page 2]
[clockwise, from top left]
Okay Mountain
Corner Store (detail) 2009
Mixed media installation, dimensions variable
Courtesy of the artists

Mark Schatz
Accumulation Study #1 (detail) 2008
Polymerized gypsum, gouache, and colored pencil,
7 × 7 × 4 in.
Courtesy of the artist

Kevin Landers
Untitled (Cool guy) (detail) 1994
C-print, 34 × 23 in.
Courtesy of the artist and Elizabeth Dee, New York,
New York

Kevin Landers
Untitled (Grate, New York) (detail) 2002
C-print, 29⅞ × 40¼ in.
Courtesy of the artist and Elizabeth Dee, New York,
New York

Tom Burckhardt
FULL STOP (detail) 2004–2005
Paint, cardboard, hot glue, wood, and metal,
216 × 216 × 120 in.
Courtesy of the artist

Mark Schatz
Googling Mackinac (detail) 2007
Collected cardboard, wood, styrene, and model foliage,
8 × 36 × 180 in., with suspended elements at
various heights
Courtesy of the artist

Mark Schatz
**A Map Drawn From Memory, Torn to Pieces, and
Thrown Into the Sea** (in process) (detail) 2009
EPS foam, wood, plaster, paints, and model foliage,
144 × 120 × 96 in.
Courtesy of the artist

[page 3]
[clockwise, from top left]
Kevin Landers
Untitled (Birdcages, Paris) (detail) 2002
C-print, 48⅞ × 29¾ in.
Courtesy of the artist and Elizabeth Dee, New York,
New York

Conrad Bakker
**Untitled Project: SUBSCRIPTION [Artforum
International September 1969–June 1970]** (detail)
2009
Oil on carved wood, 10⅝ × 10⅝ × ⅝ in.
Courtesy of the artist

Kiel Johnson
Shoot Out (detail) 2009
Chipboard, tape, glue, and acrylic sealer,
dimensions variable
Courtesy of the artist and Davidson Contemporary,
New York, New York

Conrad Bakker
**Untitled Project: BACK ISSUES [Artforum
International, Summer 1969][Stonewall Riots,
New York City, June 28, 1969]** (detail) 2009
Oil on carved wood, 10⅝ × 10⅝ × ⅝ in.
Collection of Scott and Judy Nyquist

Conrad Bakker
Untitled Project: MARKET [Geneva] (detail) 2005
Oil on carved wood, dimensions variable
Courtesy of the artist and Analix Forever, Geneva,
Switzerland

[page 4]
[clockwise, from top]
Kaz Oshiro
Disposal Bin (Light Gray with White Drips) 2009
Acrylic on stretched canvas over panel and caster wheels,
47½ × 75 × 34¼ in.
Courtesy of the artist and Yvon Lambert New York,
New York

Kiel Johnson
It Was a Quiet Day Today (detail) 2009
Ink on paper, 55 × 36 in.
Courtesy of the artist and Mark Moore Gallery,
Santa Monica, California

Kevin Landers
Untitled (Folding table with stripes) (detail) 2002
C-print, 30 × 45⅛ in.
Courtesy of the artist and Elizabeth Dee, New York,
New York

[page 7]
Tom Burckhardt
FULL STOP (detail) 2004–2005
Paint, cardboard, hot glue, wood, and metal,
216 × 216 × 120 in.
Courtesy of the artist

René Paul Barilleaux
Eleanor Heartney

NEW IMAGE

theMcNay
San Antonio, Texas

SCULPTURE

CONTENTS

CONTENTS

ACKNOWLEDGMENTS

A rich and complex subject, the evolution of sculpture from the early twentieth century to the present is an essential part of the development of modern art. With this in mind, the McNay Art Museum began to build a modern sculpture collection soon after opening in 1954 as a complement to Marion Koogler McNay's superb collection of modern paintings.

Beginning with the acquisition of works by Auguste Rodin, the collection's scope now extends from early nineteenth-century French to contemporary American works. Over the past two decades more than fifty sculptures have been acquired for the collection, including works by David d'Angers, Albert Ernst Carrier-Belleuse, Malvina Hoffman, Gaston Lachaise, David Smith, Raoul Hague, Mary Frank, Donald Judd, Beverly Pepper, Leonardo Drew, and Chakaia Booker. Moreover, solo exhibitions of works by Scott Burton, Melvin Edwards, Seymour Lipton, Elie Nadelman, George Rickey, Rodin, Joel Shapiro, and Richard Stankiewicz have appeared at the McNay, often complementing new acquisitions.

New Image Sculpture explores a recent direction in contemporary American art—albeit one with roots in radical, early twentieth-century developments—and presents a fascinating counterpoint to the collage and assemblage tradition so well represented at the McNay. Rather than employing found objects from the real world combined to create something wholly new, the artists of *New Image Sculpture* interpret objects from the real world as aesthetic objects removed from their original function. Their works question our common understanding of what is real and further expand the definition of sculpture.

René Paul Barilleaux, Chief Curator/ Curator of Art after 1945, focusing on how contemporary artists deal with representing the real world, organized the exhibition and publication documenting this significant aspect of contemporary art. I thank him for these efforts, which augment his many accomplishments at the McNay, including expansion of the museum's collection of figural and photo-based art in the five and one-half years since he joined the staff.

We are delighted to have Eleanor Heartney as guest essayist, providing a rich art historical context for the works presented. Research and organizational assistance by Andrea McKeever and Lana Shafer, Semmes Foundation Interns in Museum Studies, and by Sara Vanderbeek, former Curatorial Assistant, have provided essential components of this book. Special thanks also to Heather Lammers, Collections Manager and Exhibitions Coordinator, and Rebecca Dankert, Associate Registrar for Exhibitions, for making all logistical arrangements, and to Ethel Shipton, Chief Preparator, for directing the installation team.

Again, we are pleased to work with Ed Marquand and book designer Jeff Wincapaw of Marquand Books in producing a distinctive publication. Rose M. Glennon, Senior Museum Educator/Editor at the McNay, is responsible for skillfully editing the manuscript.

Finally, I am grateful to all the artists and lenders for their enthusiastic cooperation, and acknowledge the support provided by the McNay's three visiting artists endowments: the Flora Crichton Visiting Artist Fund, the Ewing Halsell Foundation Endowment for Visiting Artists, and the King Ranch Family Trust Endowment for Visiting Artists. In addition, I thank our individual sponsors and members of the host committee for their generous support of this project.

William J. Chiego
Director

INTRODUCTION

New Image Sculpture assembles works by emerging and mid-career artists who freely appropriate from popular and material culture, art history, ethnographic and folk art, hobby crafts, fashion, and the world of do-it-yourself. These artists transform widely available materials, many found on the shelves of hardware stores and building suppliers, into fanciful re-creations, replications, and interpretations of ordinary and mundane things. Styrofoam, corrugated cardboard, and duct tape replace marble and bronze as primary materials, while ersatz Crock-Pots, boom boxes, suitcases, and women's purses take the place previously held by portrait busts or minimalist cubes.

Drawing on art historical movements including Dada, Nouveau Réalisme, Arte Povera, and Pop art as well as various other developments in realism, and injecting a dose of elementary school arts and crafts, these disparate artists all use recognizable imagery and common materials. In much of this art, fabrication techniques are clearly conspicuous as an element of the finished work. Other characteristics include labor-intensive and obsessive approaches; emphasis on craft and the handmade, with obvious evidence of the artist's hand; and use of ephemeral materials.

To date, neither an exhibition nor a publication has examined these artists and their works, which emphasize real world imagery, incongruous materials, and skilled processes. A handful of the artists surveyed here were key in propelling this investigation forward—in particular, Libby Black, Tom Burckhardt, Chris Hanson and Hendrika Sonnenberg, Kaz Oshiro, and Jade Townsend. Encountering their art at different moments and in separate venues inspired further interest in the genre. Andrea McKeever and Lana Shafer, former Semmes Foundation Interns in Museum Studies at the McNay Art Museum, conducted in-depth research on numerous artists and artist collectives, several not represented in this survey. Sara Vanderbeek, the museum's former Curatorial Assistant, provided additional research and administrative support.

The title *New Image Sculpture* is adapted from the title for an exhibition organized in 1978 by Richard Marshall at the Whitney Museum of American Art in New York. That exhibition, *New Image Painting*, included the work of painters who also used recognizable subjects. Among them were Nicolas Africano (human figures), Jennifer Bartlett (landscape), and Susan Rothenberg (horses), three artists who continue to work with real world imagery. What Marshall said of new image painters' work can also apply to new image sculptors: "The image becomes released from that which it is representing."[1]

In her essay, Eleanor Heartney connects aspects of new image sculpture to the painting tradition known as *vanitas*. She continues with a discussion of Dada master Marcel Duchamp, then traces the roots of new image sculpture throughout the past century and into this one. Following Heartney's commentary are profiles of the artists and expanded portfolios of their work.

These thirteen artists and artist collectives represent only a small number of individuals whose sculptures can be characterized as new image. Depicting a range of subjects and employing diverse materials, each artist creates a unique vision of the world we encounter on a daily basis. Regardless of what they make or how they make it, in the end these artists transform ordinary stuff into objects of extraordinary engagement. Their achievements are celebrated here.

René Paul Barilleaux
Chief Curator/Curator of Art after 1945

1 Richard Marshall, "Introduction/New Image Painting," in *New Image Painting* (New York: Whitney Museum of American Art, 1978), 7.

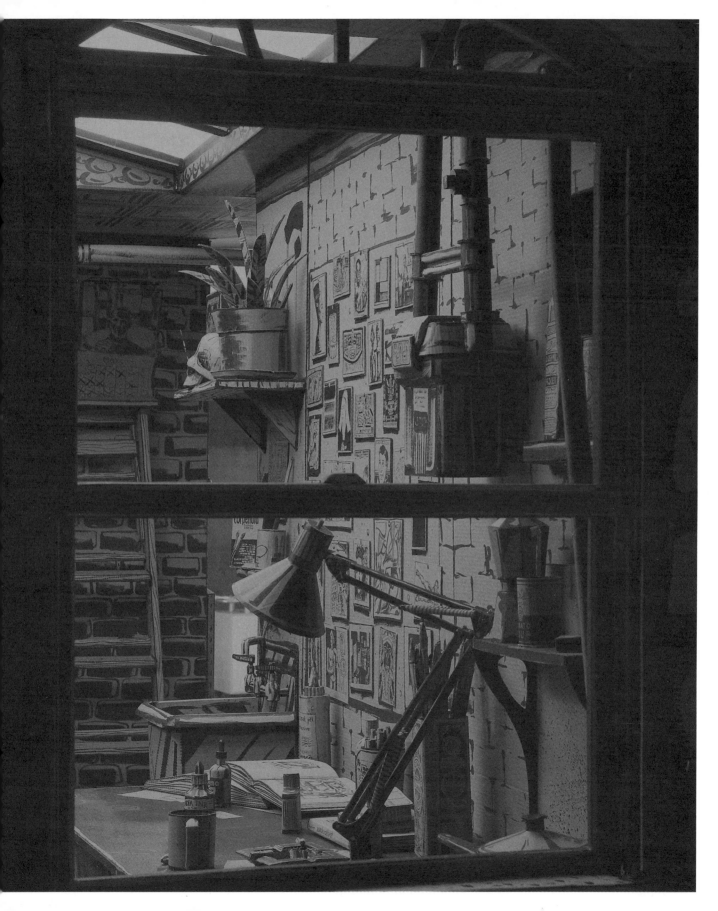

Eleanor Heartney

NEW IMAGE

In seventeenth-century Holland, realism merged with metaphor to create a remarkable subset of still-life painting: the *vanitas*, in which exactingly observed objects served as carriers of moral lessons or spiritual meaning (fig. A; all figures on p. 21). Read as warnings about the vanity of human desires, these works predicted the inevitability of death. A book suggested knowledge, a cut lemon the unavoidable decay of beauty, flickering candles the notion of time running out, and of course, the skull—death itself.

In the modern era, the vanitas painting, along with the once popular still-life tradition, has fallen out of fashion. Symbolic use of everyday objects, however, lives on in countless sculptures and installations in which artists painstakingly reproduce ordinary manufactured items that surround us every day. This tendency, considered here under the rubric *new image sculpture,* shares both the fidelity to vision and the metaphoric approach to the everyday world that animated the Dutch vanitas. While new image sculptors are not as narrowly focused on issues of mortality and guilt as their seventeenth-century ancestors, they do reveal that mass-produced objects are important elements in today's artistic vocabulary. Contemporary books, cars, and handbags are no less rife with metaphor and meaning than all those bones, cut melons, decaying flowers, and hourglasses in the traditional vanitas. When artists remake contemporary objects, they appropriate some of their magic and power.

The appearance of modern new image sculptures varies widely, ranging from roughly fabricated items whose seams, misalignments, and faux materials are clearly visible, to highly crafted reproductions that are all but indistinguishable from the original object on which they are based. Motivations differ just as much as techniques do. Some artists are drawn to the pleasure of visual trickery, as were the Dutch painters of trompe l'oeil tabletop items. Like magicians, new image sculptors convey the sense that the hand is faster, or in this case more cunning, than the eye. Others leaven their works with social commentary, reminding us of the commodity basis of modern economies, underscoring the unequal social conditions that make the global economy possible, or suggesting how communities form around specific classes of objects and environments. Still others present objects as mirrors that reflect our private desires and dreams. And some use objects as human surrogates, infusing them with the vulnerability, aggression, or generosity of those who use them.

In the process, this work raises contemporary questions: Why spend hours handcrafting a radio or a suitcase that could easily be purchased at the local discount mart? Why draw our attention to manufactured objects that, in their original state, wouldn't merit half a glance? What do our objects mean to us?

SCULPTURE

Marcel Duchamp, of course, instigated this major artistic reevaluation of ordinary objects, though things turned out rather differently than he expected. In 1917 Duchamp acquired an ordinary mass-produced urinal, titled it *Fountain,* and submitted it to the first exhibition of the Society of Independent Artists in New York (fig. B). Organizers of the show rejected *Fountain*, but the gesture secured the artist's legendary status within avant-garde circles. The significance of Duchamp's gesture has been endlessly debated—in his writings, Duchamp seemed to suggest that he was attacking the very idea of art as a separate sphere of experience.[1] However, the artist's later practice of remaking the urinal and other so-called "ready-mades" as limited edition sculptures seems to muddy that claim. After Duchamp, the mass-produced object unquestionably entered the realm of art as both subject matter and art material. This idea's repercussions have reshaped art history and continue to be felt to this day.

In the 1960s, the French Nouveaux Réalistes, among them Arman, Niki de Saint Phalle, and Daniel Spoerri, followed in Duchamp's footsteps by making art out of food, trash, and broken machines. Their work was designed to deteriorate, decay, or in the case of the junk assemblages of Jean Tinguely, literally self-destruct. In Italy in the 1970s, sculptures by Arte Povera artists such as Jannis Kounellis, Mario Merz, and Gilberto Zorio similarly employed bottles, coal, live animals, plants, sheets of glass, silk, umbrellas, and wood, and drew on elemental forces like condensation, electricity, evaporation, and fire. In the United States, this approach never took on movement status but iconic works manifested the impulse, such as Robert Rauschenberg's Combines, which incorporated paint and real objects, among them his own bed and a stuffed goat. Taking the incorporation of objects in a different direction, Joseph Cornell created dreamlike assemblage boxes put together with elements like broken mirrors, butterfly wings, magazine cutouts, marbles, and scraps of wallpaper.

In the past century, the artistic use of objects has branched in two directions. On the one hand, artists like those above used found objects to construct assemblages and sculptures. More recent manifestations include Jessica Stockholder's three-dimensional environments constructed from elements like a chest of drawers, curtains, electric fans, and plastic buckets (fig. C); and Tony Cragg's silhouette works composed of colorful plastic detritus scavenged from dumpsters and beaches.

A separate branch of this family involves re-creation of ordinary objects out of other materials. Jasper Johns's *Painted Bronze* (1960) replicates two ordinary Ballantine Ale cans (fig. D). In Claes Oldenburg's *Store* (1961), he sold plaster sculptures of food and other domestic items; his later public art projects reproduce baseball bats, clothespins, pencils, and umbrellas as monumental forms. Richard Artschwager's faux furniture and accessories are minimalist forms resembling chairs, tables, and framed pictures through the artful use of woodgrain Formica veneer. More recently, the tendency reappears in the works of Robert Gober, who fabricates extremely convincing versions of everything from lawn furniture to human legs; Jeff Koons, who creates aluminum replicas of children's inflatable toys; and Charles LeDray, who makes

miniature versions of clothing and hand-thrown pots.

New image sculptures issue from this second branch; all are replications of familiar objects of contemporary life. In re-creating industrially produced objects by hand, the artists debate the meaning of labor and the consequences of mass production that goes back to the beginning of the industrial age. Victorian writers like William Morris and John Ruskin reacted with horror to the dehumanizing effects and shoddy craftsmanship of machine production.[2] By establishing the nineteenth-century Arts and Crafts Movement, they hoped to revive the joyful sense of labor romantically attributed to the medieval worker. By contrast, Walter Benjamin, writing in 1936, celebrated what he saw as the liberating potential of the machine to free workers from tedious employment,[3] and he cheered the demise of the aura of uniqueness that surrounded traditional works of art. The new image sculptors are heirs of both attitudes. They are enthralled by the mass-produced object, yet devoted to handcrafting their works. The tension between these two positions is part of what makes their art so compelling.

These new image sculptures partake in a dialogue identified with art critic and philosopher Arthur Danto. Danto often cites his epiphany upon his first encounter with Andy Warhol's *Brillo Boxes* (fig. E) in 1964.[4] *Brillo Boxes* was a completely faithful replica of the cartons then created to hold commercial soap pads, down to the jazzy screenprinted logo on the boxes. Warhol's version, however, was created out of plywood rather than cardboard. When Danto saw an exhibition of Warhol's *Brillo Boxes* at the Stable Gallery in New York, he recognized these works as the culmination of modern art's search for meaning. By posing a distinction between two things that were visually indistinguishable, namely the real Brillo boxes and their sculptural counterpart, Danto notes that "art had raised, from within and in its definitive form, the question of the philosophical nature of art."[5] This revelation sent Danto on a philosophical quest for the definition of art and ultimately led him to suggest that art is distinguished from other objects in the world, not by the way it looks, but by its place within a larger philosophical conversation about the meaning of objects.

The artists here extend Danto's idea into a number of different realms. Perhaps closest to the spirit of the *Brillo Boxes* are several works that use ordinary objects to reflect on art and the art world. Kaz Oshiro creates what appear to be familiar appliances, cases, stereo amps, and kitchen cabinets out of canvas stiffened with layers and layers of acrylic gesso, then painted to complete the illusion. He chooses objects with simple rectangular shapes that recall the resolutely nonfunctional works of sculptors like Carl Andre and Donald Judd. Thus these works deliberately confound the categories with which we usually classify works of art. These paintings look like sculptures and are realist works that blend the quotidian subject matter of Pop art with the clean geometry of Minimalism. Their larger meanings, as Danto suggests, lie in the way they challenge our understanding of contemporary art.

Something similarly challenging occurs in the work of Mark Schatz, whose subjects involve equally reductive facsimiles of objects like recliners, storage boxes, and suitcases. Schatz, however, creates from sculptural materials like polystyrene and cement. As a result these supposedly portable objects are rendered solid and

immobile. Here, the application of the minimalist aesthetic to recognizable objects yields sculptures designed to thwart fantasies of progress, movement, or escape suggested by the usual functions of the items represented.

By contrast, Tom Burckhardt is more interested in the artist's activity than in the objects of art. He has produced a full-scale replica of an artist's studio out of cardboard, complete with tools, art supplies, art books, and references to art historical figures like Duchamp and Pablo Picasso. He also fashions humorously slumping painted canvases, also out of cardboard, that rest on constructed paint cans and shipping crates. These works, dragged down by gravity or their own unfulfilled expectations, become surrogates for their creator and suggest the psychological state of the discouraged artist who can't quite get things right.

Other new image sculptors use replicated objects to pursue meditations on commerce. Here they draw on and extend the commodity critique that runs throughout contemporary art, starting with Warhol who declared that "being good in business is the most fascinating kind of art."[6] The often murky relationship between art and commerce motivates artists in the post-Warhol era in many ways, ranging from Haim Steinbach's arrangements of fetishistic consumer products on streamlined Donald Judd-inspired shelves, to Takashi Murakami's Warhol-inspired factory and Sylvie Fleury's shopping bags full of a day's purchases of designer clothing and cosmetics. Such works acknowledge art's place within the market system, its role as a luxury good, and its relationship to other commodities. Conrad Bakker deals with these issues head

on, creating sculptures that operate, at least partially, as substitutes for the commercial objects they replicate. Creation of his carved wooden replicas of things like books, trash cans, and folding tables is only the beginning. He then sends them out into the real world, selling them on eBay or craigslist under the appropriate categories for the original objects, placing them in the stores that sell the real things, replacing gift cards in museum shops with his exact painted replicas, all to be sold for the same prices.

Okay Mountain collective, a group of ten artists based in Austin, Texas, works along similar lines, even creating a replica of a convenience store in the middle of an art fair. The store's shelves were stuffed with eye-catching packages of cigarettes, hardware, magazines, snack items, toys, and other products one might find in this setting, all of them fabricated anew. The collective also reproduced advertising posters, store furniture, and even the ubiquitous security monitor. In the context of an art fair or an art museum, the work humorously suggests both the difference and the similarity between certifiable works of art and the disposable odds and ends purveyed at the corner store.

Also interested in commerce, Libby Black remakes objects that hail from the luxury end of the commodity spectrum. She notes that this work actually emerges from her own discomfort in high-end retail stores; to counter this uneasiness, she employs her signature materials of paper, hot glue, and acrylic paint to fill the shelves of faux designer shops with champagne buckets, Gucci shoes, Louis Vuitton handbags, and workout equipment emblazoned with designer labels. She creates a life-sized Mercedes Benz out of paper, acrylic, and glue.

By constructing these high-end objects out of low-end materials, she challenges our assumptions about the status attached to luxury goods.

New image sculptures throw light on the mechanisms of commerce, our various systems of exchange, and how objects serve as currency. Furthermore, commercial products present a portrait of our desires. Like Black and Okay Mountain collective, Kevin Landers crafts faux commercial displays, aiming to evoke the urban scene rather than critique our economic system. Displays of knock-off watches, racks of chips, and lotto tickets stacked on a counter are part of the backdrop of city life. Fabricated from materials like metallic tape, mylar, plastic, Plexiglas, vinyl, and wire, the presentations demand a double take, serving as symbols of who we are and who we hope to be.

Even more explicit about the way that objects around us shape our self-image, Jean Lowe is interested in the contrast between our exalted dreams and our mundane realities. Many of her installations use grand period vocabularies to carry social critiques. Other works focus on our manias for therapy and self-help, re-creating racks of papier-mâché books whose titles promise impossible physical and spiritual improvements. These books hail from the world of daytime talk shows, and Lowe satirically exaggerates their claims to suggest how deeply attached we are to the notion that self-absorption is indistinguishable from self-improvement.

Chris Hanson and Hendrika Sonnenberg focus on objects that reference the violence and mass psychology embedded in popular culture. Their Web site Bucket of Blood[7] shares its name with a Roger Corman horror movie in which a Beat-era busboy becomes a successful artist by killing people and covering their corpses with plaster. Like equally obsessed creators, Hanson and Sonnenberg carve replicas of objects out of polystyrene foam: hockey scoreboards, rock concert amps, tangles of microphones, and chain-link fences. Pastel blue and green hues give them a strangely frosty quality. Adding to the unsettling aura is the dysfunctional or intentionally damaged appearance of these objects. As a result, the works suggest that dark undercurrents motivate the group rituals of contemporary society, which the objects signify.

Dennis Harper takes a lighter view of popular culture. From Harper's background in underground comics, his objects conjure up alternate worlds. One body of works, titled *Ritual Prototypes for the Afterlife*, offers an updated version of items in King Tut's tomb. It includes a video interview with a reincarnated Tut as a crotchety middle-aged man with modern funeral artifacts such as a La-Z-Boy supported by the Egyptian jackal god, Anubis, and a flat screen TV that plays the interview above. Other Harper works seem to be stand-ins for entire lifestyles, lovingly re-created in every detail, such as his *Paper Motorcycle*, which includes paper oil spots on the floor, or his levitating paper Steinway piano suspended from the ceiling with thin wires.

In a similar spirit, Kiel Johnson presents a lost world of outmoded technology. Media and communication modes of a bygone era particularly fascinate Johnson, the son of a newspaper publisher. His *Publish or Perish* represents a roll feed offset printing press made out of cardboard and metal, while *Twin Lens Reflex Camera* is a giant camera obscura also

created from cardboard. *Export the Output* uses the same material to fashion a ramshackle collection of outmoded recording devices. A certain pathos resides in these nonfunctional machines, once technologically current sources of vital information, but now sidelined by the Internet and the digital world.

Jade Townsend's environments allude to natural and human-created disasters. He often combines obviously fake objects with realistic figural sculptures to suggest unsettling narratives. He turns inside out a house with its contents strewn about as if spilling its guts and along with them the domestic dream that this structure signifies. Workers pull apart a shed with a giant golden egg inside, echoing the destruction of the golden goose of fairy tale fame. A fissure in a prison-like façade reveals a white desk, a chair, and a small, comfortably suburban reading lamp.

A recent work is a three-part meditation on the consequences of excess consumption and the apparent futility of political revolution. Townsend combines architecture, figural sculptures, and machinery to both mock and lament our social obsessions, while offering a touch of hope with the inclusion of a small room where viewers can retire, removing themselves temporarily from the never-ending cycle of greed and deprivation. Such works suggest a world where the ordinary is always being invaded by the extraordinary.

Finally, Margarita Cabrera serves notice that even the most apparently inconsequential objects come from somewhere, that their creation and distribution is inevitably bound up in politics and economics. As a Mexican American based in El Paso, Texas, she is keenly aware of the role played by sweatshop labor, border issues, and immigration in the products we use. As with Townsend's work, the objects she re-creates are all attached to larger political narratives: a soft vinyl Volkswagen Beetle pays homage to the vehicle commonly used in Mexico for low-cost transportation, while appliances like blenders, slow cookers, and vacuum cleaners are made in maquiladoras by sweatshop laborers in Mexican towns bordering the United States. In all of Cabrera's works, "labor" has multiple meanings, referring both to her own re-creation of factory goods and to the economic exploitation of Mexican workers who make these goods for the American market.

Taken together, new image sculptures offer compelling meditations on the meaning of labor, the creation of value, the construction of personal and social identity, and the nature of art. With respect to the latter, they confirm Danto's notion that art is not a function of the way an object looks, or even of its inherent aesthetic qualities. Rather, something becomes art when it contributes to the ongoing discussion about art's place in the world and the way it shapes our understanding of the meanings and purpose of life. From this perspective, these works of art reveal the many ways that we are entangled with the objects that surround us. Objects help define who we are and they inform our possibilities. They also, on occasion, keep us from moving forward. By shining a spotlight on the world of objects, so often hidden in plain sight, and remaking them out of unexpected materials, the artists evoke the world of desire, dread, nostalgia, and comedy that envelops us all the time.

1 Pierre Cabanne, *Dialogues with Marcel Duchamp* (1979; repr., Cambridge, MA: Da Capo Press, 1987).
2 See, for instance, John Ruskin, *On the Nature of Gothic Architecture: And Herein of the True Functions of the Workman in Art* (1854; repr., Whitefish, MT: Kessinger Publishing, 2008) and E. P. Thompson, *William Morris: Romantic to Revolutionary* (1955; repr., Stanford, CA: Stanford University Press, 1988).
3 Walter Benjamin, "The Work of Art in the Age of Mechanical Reproduction," in *Illuminations*, ed. Hannah Arendt, trans. Harry Zohn (New York: Schocken Books, 1969).
4 See, for instance, Arthur C. Danto, *Andy Warhol* (New Haven, CT: Yale University Press, 2009), 47–71.
5 Ibid., 65.
6 Andy Warhol, *America* (New York: Harper & Row, 1985), 8.
7 http://www.bucketofblood.net/ (accessed June 30, 2010).

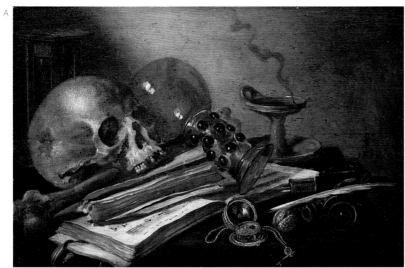

A

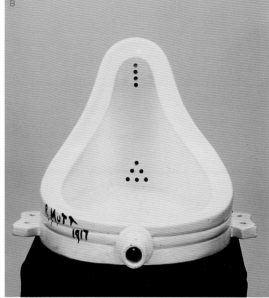

B

C

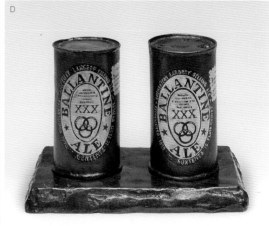

D

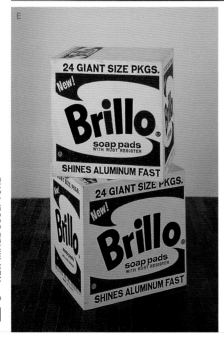

E

figure A
Pieter Claesz.
Vanitas-Still Life 1656
Oil on oakwood, 15½ × 23¾ in.
Collection of Kunsthistorisches Museum, Vienna, Austria

figure B
Marcel Duchamp
Fountain 1917/1964
Third version, replicated under the direction of the artist
in 1964 by the Galleria Schwarz, Milan, Italy.
Collection of Musée National d'Art Moderne,
Centre Georges Pompidou, Paris, France
© 2010 Artists Rights Society (ARS), New York/ADAGP,
Paris/Succession Marcel Duchamp

figure C
Jessica Stockholder
2006
Fluorescent light, bicycle rack, plastic waste basket, plastic
thermos, red light bulb and fixture with plastic pitcher
shade, yellow plastic crates, electric wires, wooden stool
and bench, plywood, rubber mat, metal flashing, plastic
ties, acrylic and oil paint, and orange weight for weight
lifting, 64 × 81 × 80 in.
Private collection, courtesy of the artist and Mitchell-Innes
& Nash, New York, New York

figure D
Jasper Johns
Painted Bronze 1960; cast and painted 1964
Painted bronze, 5½ × 8 × 4¾ in. each
Collection of the artist
Art © Jasper Johns/Licensed by VAGA, New York,
New York

figure E
Andy Warhol
Brillo Boxes 1964
Synthetic polymer paint and silkscreen on wood,
17⅛ × 17 × 14 in. each
Purchase, The Museum of Modern Art, New York, New York
© 2010 The Andy Warhol Foundation for the Visual Arts,
Inc. / Artists Rights Society (ARS), New York

ARTISTS PROFILES

Jade Townsend
YARDSALE 2008
Mixed media installation, dimensions variable
Courtesy of the artist and Priska C. Juschka Fine Art,
New York, New York

AND PORTFOLIOS

ARTFORUM

SUMMER

CONRAD BAKKER's art

appears in many places—on exhibition in museums, on the walls of art galleries, on tables at garage sales, online on eBay, and even on urban sidewalks. In an ongoing series, for example, Bakker recreates familiar, everyday products at their actual size, which he sells on the consumer market. Ranging from old typewriters and flashlights to paperback novels and VHS tapes, his nonfunctional replications are characteristically shaped from wood and painted with oils, with no attempt to disguise their painterly qualities. Bakker sells them to consumers—some of whom are art collectors—through a variety of outlets: sometimes at auction on eBay, other times at garage or sidewalk sales that he organizes for the public.

Bakker's other projects actively engage his audience in similar ways. He has fabricated articles found on store shelves in his characteristic painterly manner, then placed them back in the store's inventory among the actual products they mimic. He has replicated rubber bands or plastic cup lids and left them on sidewalks along with real debris. Bakker has even created a full–size trash dumpster, made from recycled plywood, that he sited near a building on a university campus. Actually used for refuse disposal, the dumpster sculpture also became a site for graffiti.

An exchange with his audience is key to much of Bakker's art. Multiple copies of his carved and painted version of the VHS tape of Richard Linklater's 1991 film *Slacker* were rented on a nightly basis to gallery patrons. In his recent *Untitled Project: Book-of-the-Month Club*, consumers (and collectors) enroll as club members and regularly receive opportunities to acquire one of Bakker's carved and painted books. With these endeavors, Bakker intends to "engage a variety of social, institutional, and consumer contexts, utilizing humor, contextual awareness, formal play, interventionist strategies and imperfect carving and painting techniques."[1]

Whether by choice or by chance, Bakker makes art that may or may not find a home and endure. Through his unique approach to creating art and the democratic way he releases his creations into the world, Bakker allows nearly anyone to be an art collector. Taking a broader view, the artist sees his practice in a more participatory way, with a "focus on the everyday economies of things, economies being a tangible network of relations between persons and things."[2]

Born in 1970 in Ontario, Canada, Conrad Bakker received a Bachelor of Fine Arts from Calvin College in Grand Rapids, Michigan, in 1992, and a Master of Fine Arts from Washington University in Saint Louis, Missouri, in 1996. For the past decade Bakker has been based in Urbana, Illinois, while his work appears in exhibitions internationally.

1 Conrad Bakker, http://www.untitledprojects.com/index3.php (accessed July 6, 2010).
2 Conrad Bakker, email message to René Paul Barilleaux, July 26, 2010.

[page 24]
Untitled Project: BACK ISSUES [Artforum International, Summer 1969][Stonewall Riots, New York City, June 28, 1969] (detail) 2009
Oil on carved wood, 10⅝ × 10⅝ × ⅜ in.
Collection of Scott and Judy Nyquist

Conrad Bakker in his studio.

Untitled Project: GIFTCARD [Des Moines Art Center] 2007
Oil on carved wood, 2¼ × 3½ × ⅛ in.
Courtesy of the artist and Lora Reynolds Gallery, Austin, Texas

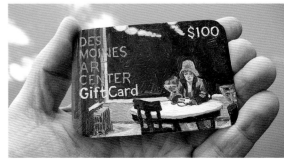

Untitled Project: SIGN [Please Pay Attention]
(detail) 2008
Oil on carved wood, 50 × 16 × 8 in.
Courtesy of the artist and Analix Forever, Geneva,
Switzerland

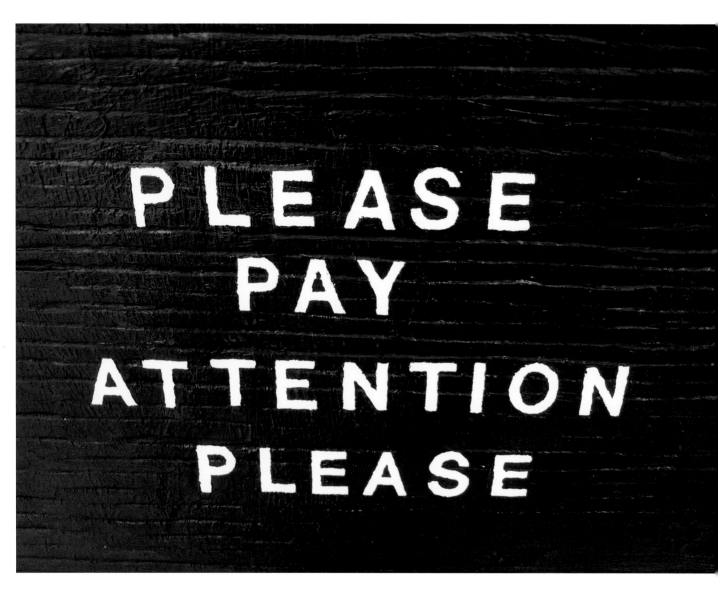

**Untitled Project: MUSEUM SHOP [Protect Me From
What I Want]** 2007
Oil on carved wood, 4 × 8 × 9½ in.
Private collection

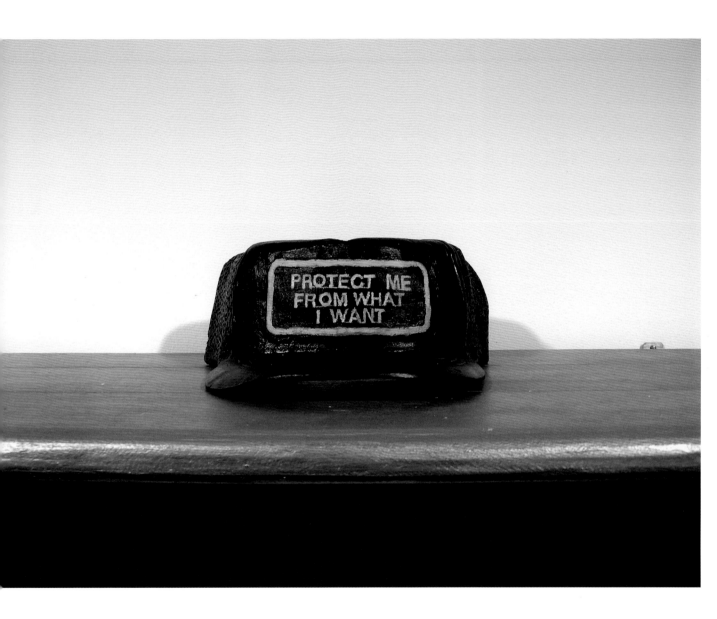

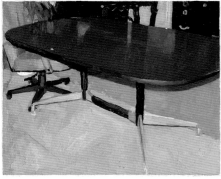 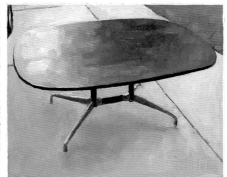 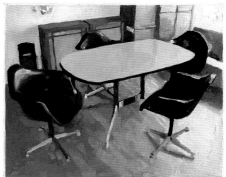

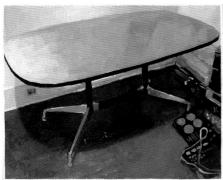

Untitled Project: EAMES TABLE
[craigslist: Herman Miller Eames Table $899] 2009
Oil on panel, 7 × 9 × ½ in.
Courtesy of the artist and Lora Reynolds Gallery,
Austin, Texas

Untitled Project: EAMES TABLE
[craigslist: HERMAN MILLER Table/Chair Set -
$850] 2009
Oil on panel, 7 × 9 × ½ in.
Courtesy of the artist and Lora Reynolds Gallery,
Austin, Texas

Untitled Project: EAMES TABLE
[craigslist: Eames / Herman Miller Conference
Table 6' - Vintage Oak - $450] 2009
Oil on panel, 7 × 9 × ½ in.
Courtesy of the artist and Lora Reynolds Gallery,
Austin, Texas

Untitled Project: EAMES TABLE
[craigslist: Herman Miller Eames Table Dining /
Conference / Desk - $1195] 2009
Oil on panel, 7 × 9 × ½ in.
Courtesy of the artist and Lora Reynolds Gallery,
Austin, Texas

Untitled Project: EAMES TABLE
[ebay: ORIGINAL HERMAN MILLER ROSEWOOD
SIGNED CONFERENCE TABLE $2295] 2009
Oil on panel, 7 × 9 × ½ in.
Courtesy of the artist and Lora Reynolds Gallery,
Austin, Texas

Untitled Project: EAMES TABLE [Studio] 2009
Oil on carved wood, 28 × 72 × 42 in.
Courtesy of the artist and Lora Reynolds Gallery,
Austin, Texas

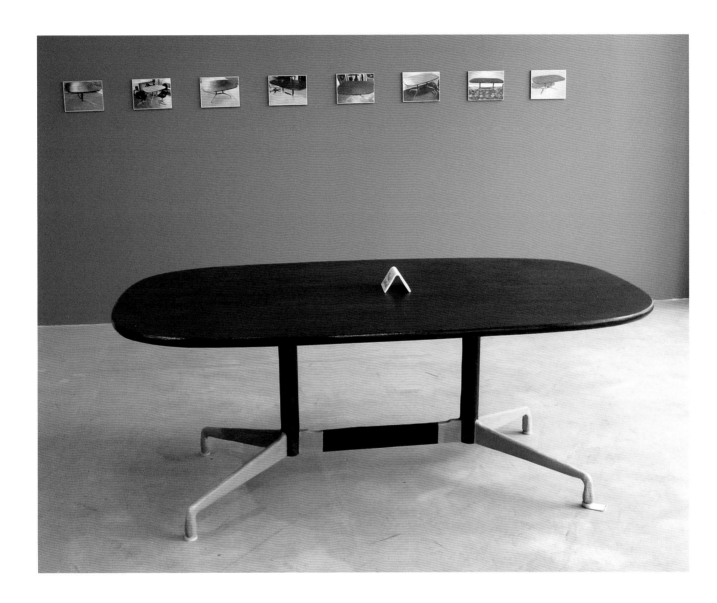

Untitled Project: PAPERBACK [Idea Art] 2009
Oil on carved wood, 7 × 4½ × 1 in.
Courtesy of the artist and Analix Forever, Geneva,
Switzerland

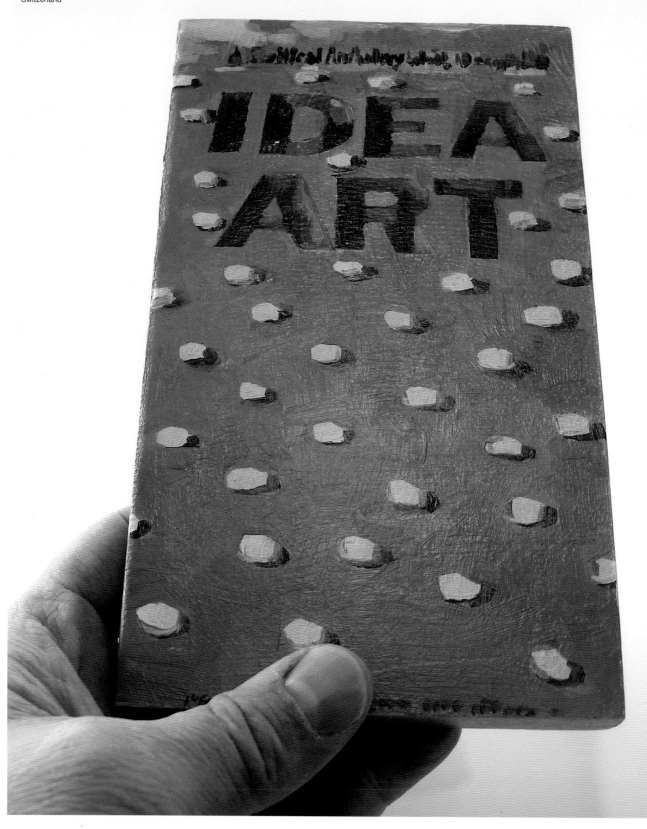

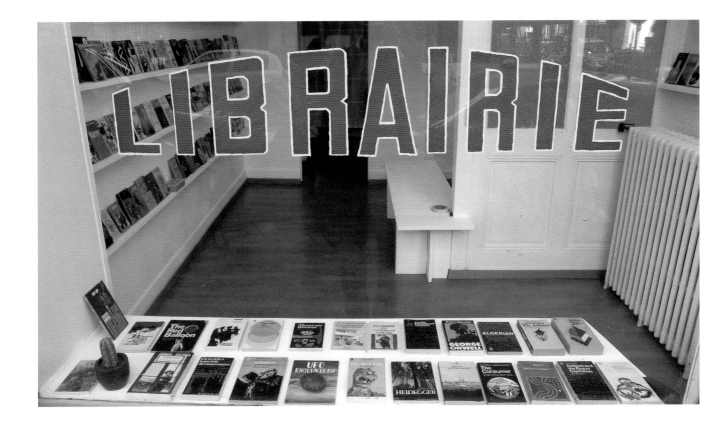

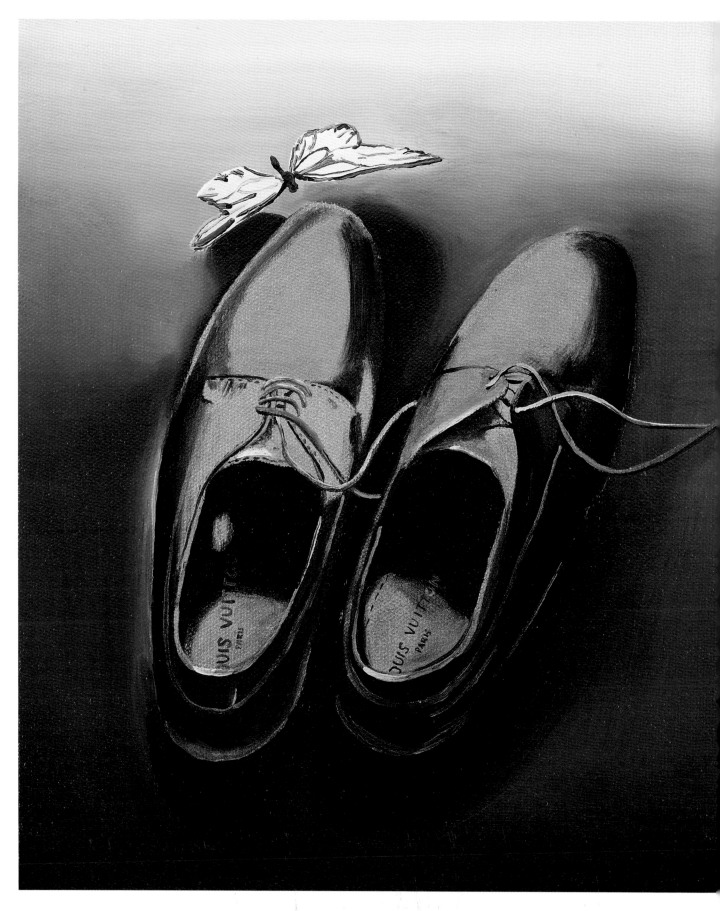

Global obsession with luxury items, designer brands, and symbols of status and wealth has created an international market for fake Prada shoes, faux Chanel purses, and "smells like" perfumes. For many, a high profile and well-placed designer logo is infinitely more desirable than a product made with quality materials by skilled labor. **LIBBY BLACK** elevates this consumer cultural phenomenon to the level of fine art in her sculptures and installations. Her art appropriates the language and iconography of wealth and power, transforming it with paper, paint, and a lot of hot glue. Black grew up during the consumer-driven 1980s, which no doubt strongly influenced her future art. Television programs and Hollywood films of the decade included such notables as *Lifestyles of the Rich and Famous* and *Wall Street*.

Black's objects make no attempt to hide the fact that they are handmade and hand painted. But unlike the authentic Louis Vuitton steamer trunk that serves as the source for her version, Black's replication clearly reveals the artist's touch in both look and attitude. The famous gold-on-brown LV repeat pattern awkwardly embellishes the exterior of the artist's trunk, and a funky gold lock secures the valuables certain to be inside. Instantly recognizable Burberry plaid, the interlocking Cs of the Chanel logo, even price tags bearing a series of "mark downs"—all find a place in this world. Sometimes these creations exist as unique objects; at other times they are incorporated into small tableaus or even large installations.

The cheap, ephemeral materials that Black employs enhance the irony in the work. High-priced goods are normally made from expensive materials. Made from synthetic and sub-standard materials, black market fakes hawked by sidewalk vendors now exist somewhere between the genuine manufactured articles and Black's artistic interpretations of them.

To broaden her critique of contemporary culture, Black also invents fantasy products bearing the same big names. Is a surfboard by Prada or a canoe by Gucci really that hard to imagine? While provoking an initial humorous response, these items, on second thought, do not appear altogether absurd. In Libby Black's art, there is no fake or faux or smells-like. Here, everything is just as it appears, but appearance after all isn't everything.

Libby Black was born in Toledo, Ohio, in 1976. She received a Bachelor of Fine Arts from the Cleveland Institute of Art, Ohio, in 1999, and a Master of Fine Arts from the California College of Arts and Craft, San Francisco, in 2001. She is based in Berkeley, California.

[page 32]
There's No Place Like Home (detail) 2007
Oil on canvas, 12 × 9 in.
Private collection

LV Cosmetic Case 2004
Paper, hot glue, and acrylic, 3 × 18½ × 15 in.
Private collection

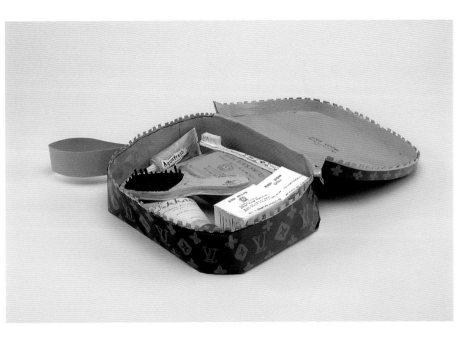

Louis Vuitton Soccer Ball 2004
Gouache and graphite on paper, 14 × 11 in.
Private collection

Gucci Handbag #1 2004
Gouache and graphite on paper, 14 × 11 in.
Private collection

Louis Vuitton Classic Tent 2004
Gouache and graphite on paper, 14 × 11 in.
Private collection

Louis Vuitton & Nike Sneakers 2004
Gouache and graphite on paper, 14 × 11 in.
Private collection

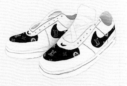

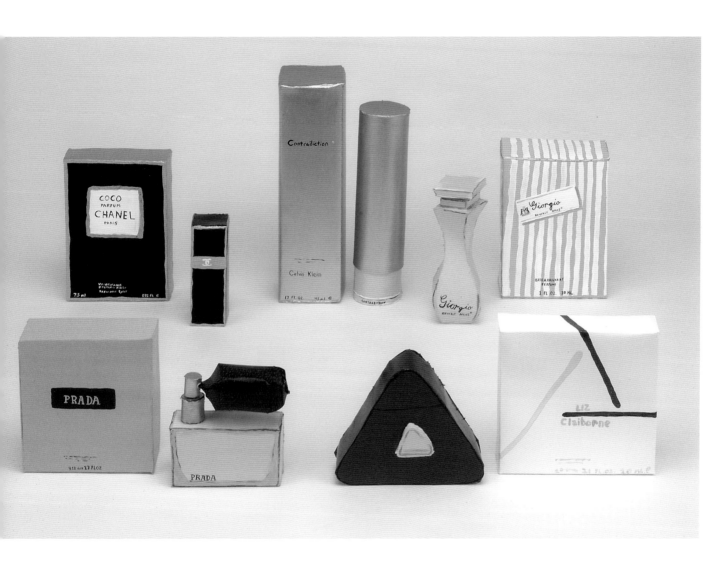

**Chanel, Calvin Klein, Giorgio, Prada,
and Liz Claiborne** 2004
Paper, hot glue, and acrylic, dimensions variable
Private collection

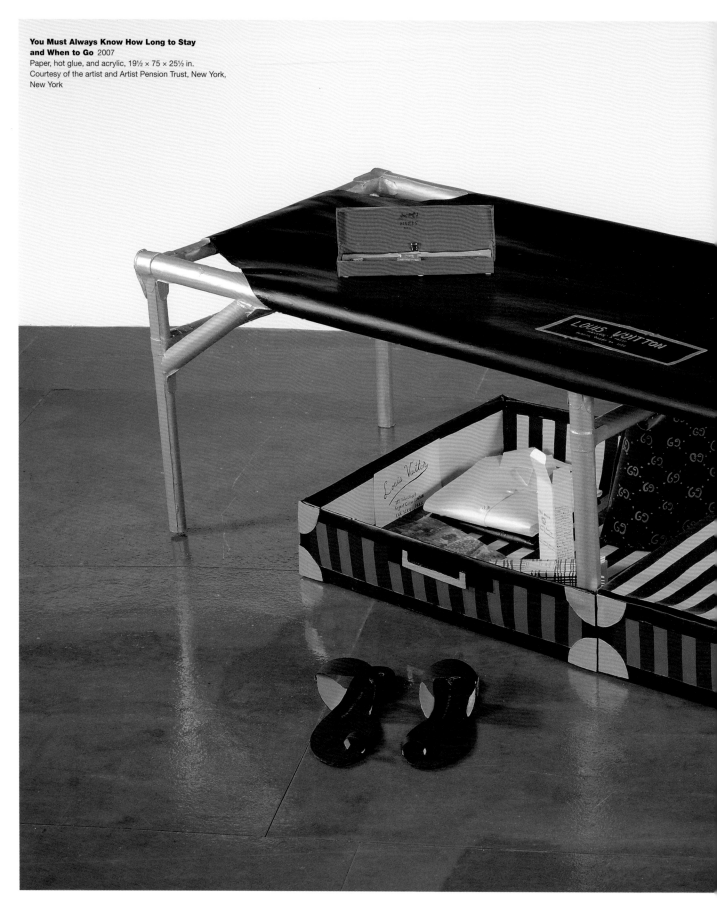

**You Must Always Know How Long to Stay
and When to Go** 2007
Paper, hot glue, and acrylic, 19½ × 75 × 25½ in.
Courtesy of the artist and Artist Pension Trust, New York,
New York

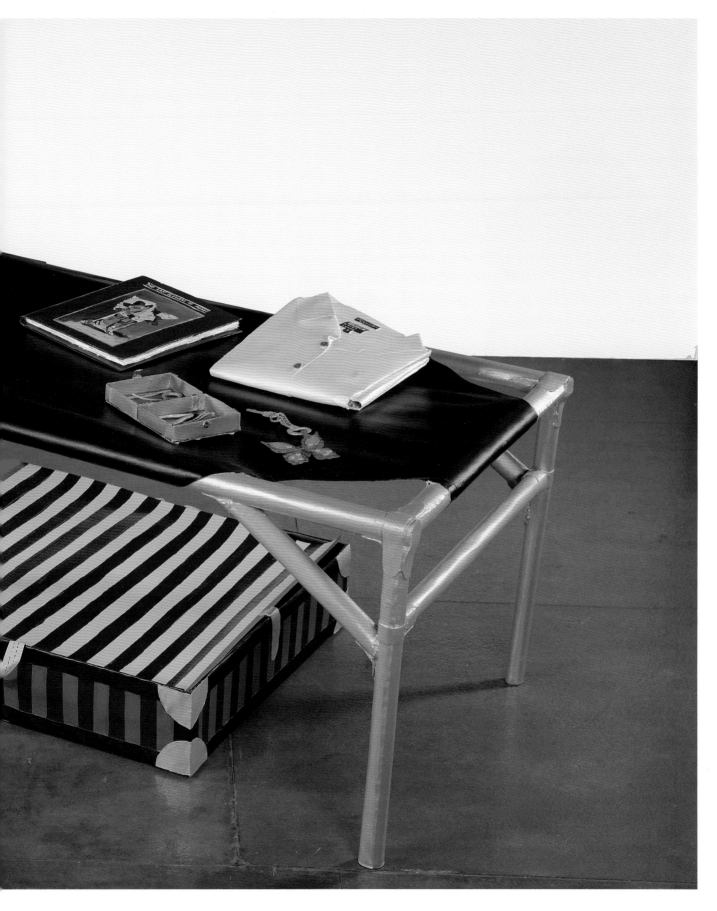

Skateboards: D&G, Gucci, Surf Jet 2010
Paper, hot glue, and acrylic, dimensions variable
Courtesy of the artist and Marx & Zavattero, San Francisco,
California

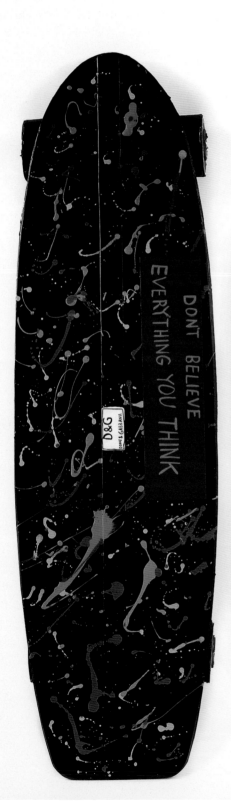

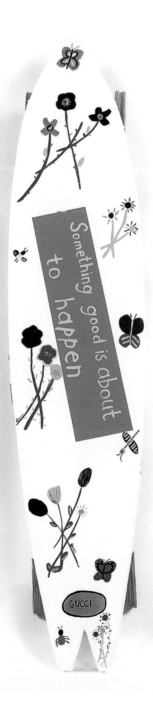

Trunks 2006
Paper, hot glue, and acrylic, 74 × 44 × 23 in.
Courtesy of the artist and Marx & Zavattero, San Francisco,
California

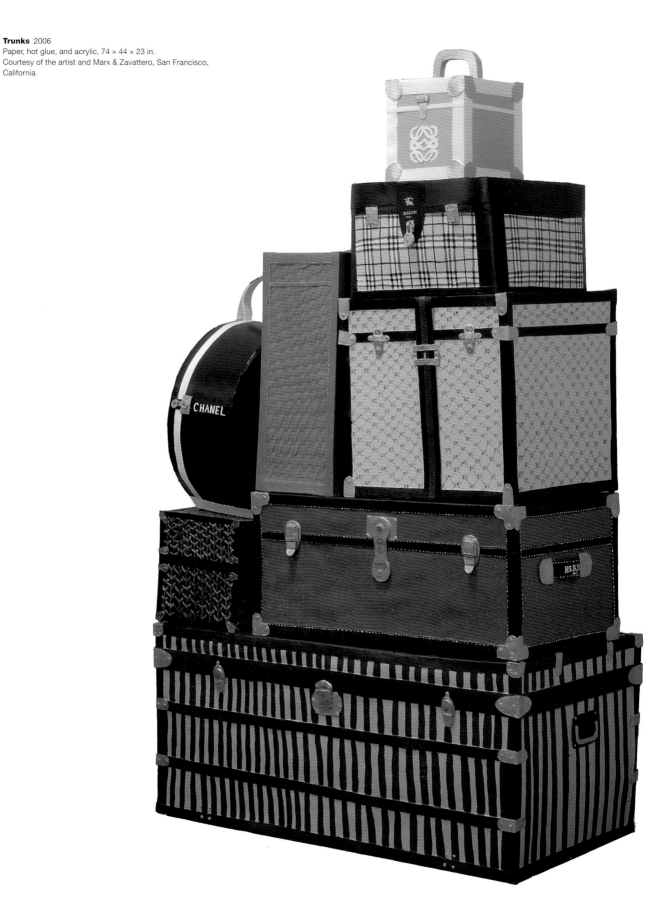

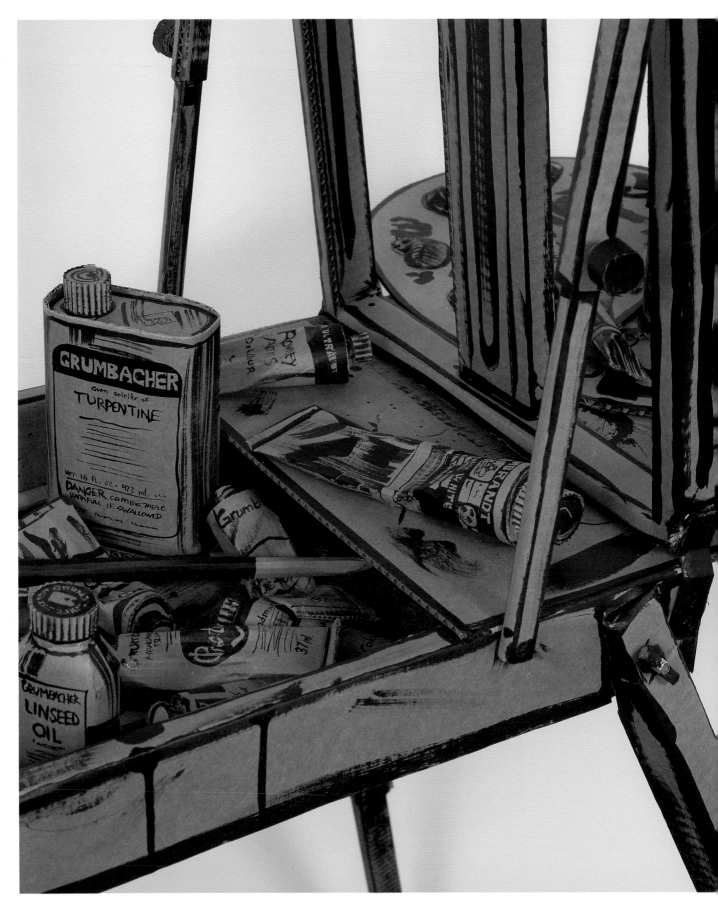

TOM BURCKHARDT's

2004–2005 tour-de-force installation *FULL STOP* envisions a painter's studio with references to art giants such as Edward Hopper, Jasper Johns, and Jackson Pollock. Fashioned from cheap corrugated cardboard, *FULL STOP* typifies Burckhardt's interest in mining the history of painting and in using commonplace materials. While first and foremost a painter, Burckhardt makes three-dimensional objects—many brightly colored and often humorous—that comment wryly on the nature of painting and the elevation of artists to mythic status.

Despite the monochrome palette of *FULL STOP*, Burckhardt's inventive sensibility and skillful fabrication of the detailed components suggest the wide range of colors found in real life. Canvases, paint tubes, artist's brushes, studio furniture, art books, postcards of favorite or revered artworks tacked to the walls, even a carousel slide projector, are all fabricated in brown and black. The viewer enters the installation as one enters the architecture of a real studio, simultaneously surrounded by the past and present. A large blank canvas on an easel anticipates equally a future masterpiece or the possible death of inspiration, with no more work to come.

In other Burckhardt works, such as the Slump series first shown in 2008, vivid colors and painterly surfaces are hallmarks. In the Slump series, bright surrogate paintings lean against the wall, or on boxes, sometimes in small groups or perched atop paint cans, their rigid rectangular forms relaxed into curves. Images in the slumped works reference a range of painting traditions, both abstract and representational. Like the studio environment of *FULL STOP*, the Slump sculptures refer broadly to the history of Western art: "Painting is not dead, but it too can seem a bit beleaguered. As a young artist, my energy and idealism was unbounded. At this point, in middle age, I need to reignite my love of the act of painting. I want to have it all, and this form of artmaking is my way of having

descriptive and abstract painting co-exist in a unique way."[1]

With or without a vast knowledge and understanding of art history, and particularly of modern and contemporary art, viewers still appreciate the insider perspective pervasive throughout this work. In Burckhardt's hands, painting and sculpture collide to become art about art.

Son of artists Yvonne Jacquette and Rudy Burckhardt, Tom Burckhardt entered the art world at birth in 1964 in New York. He studied at the State University of New York in Purchase, earning a Bachelor of Fine Arts in 1986. That year he also completed a residency at the celebrated Skowhegan School of Painting and Sculpture in Maine. For over two decades Burckhardt worked as an assistant in the studio of artist Red Grooms, noted for cartoonish imagery that often takes the form of sculpture and environments. Pop art references abound in Burckhardt's work, as do allusions to modernist and trompe l'oeil painting, hyperrealist sculpture, and optical works. He continues to live in New York.

1 Caren Golden Fine Art, New York, "Slump: Tom Burckhardt," news release, 2008, http://www .carengoldenfineart.com/exhibition/view/1407 (accessed July 6, 2010).

[page 40]
Landscape (detail) 2006
Paint, cardboard, hot glue, and wood, 67 × 40 × 48 in.
Courtesy of the artist

Pallet Table 2005
Ink on paper, 24 × 30 in.
Courtesy of the artist

Studio Fire 2006
Ink on paper, 44 × 60 in.
Courtesy of the artist

Work Table 2006
Paint, cardboard, hot glue, and wood, 47 × 44 × 32 in.
Courtesy of the artist

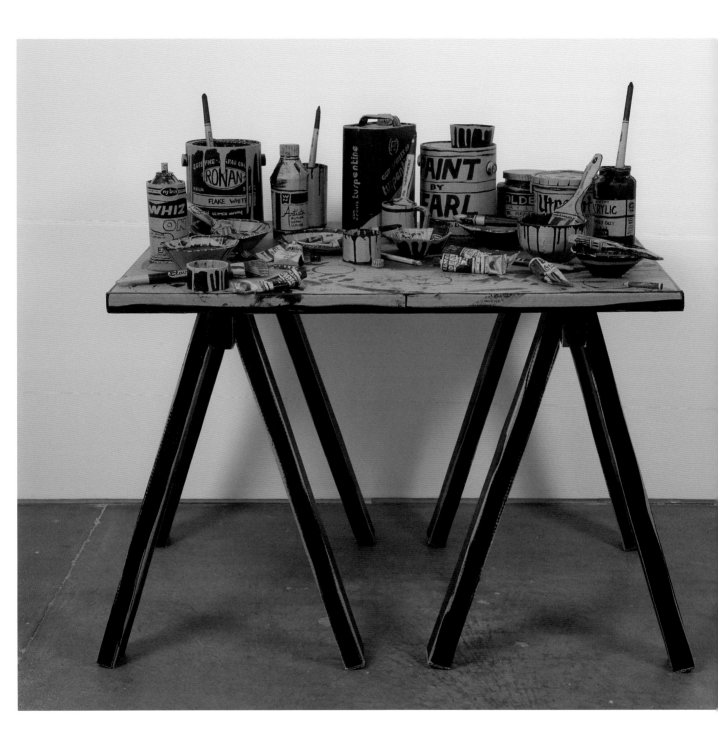

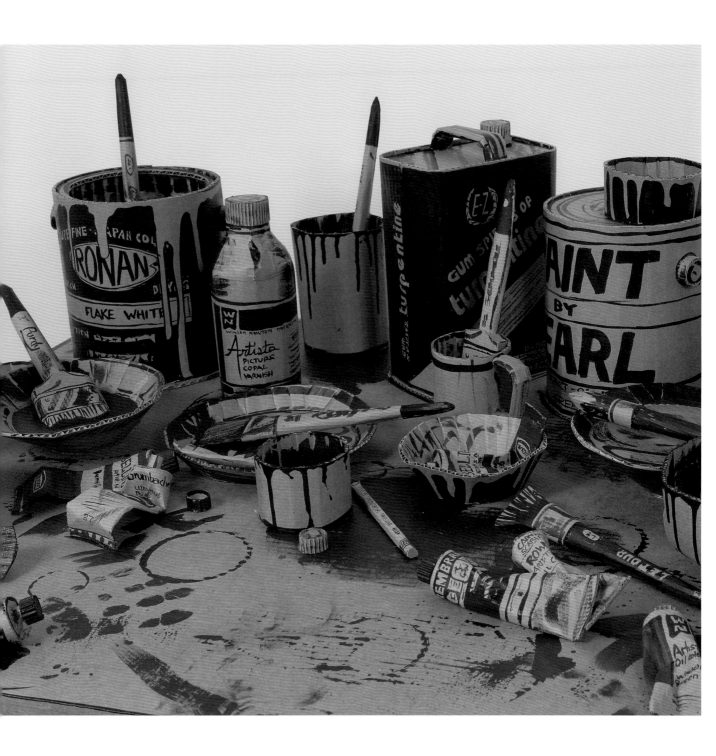

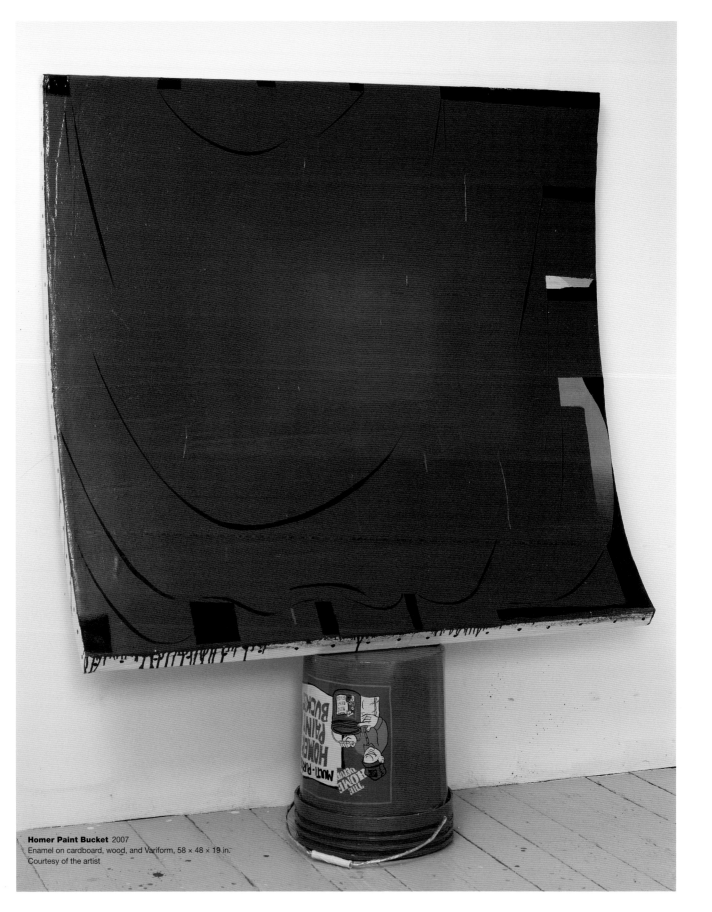

Homer Paint Bucket 2007
Enamel on cardboard, wood, and Variform, 58 × 48 × 19 in.
Courtesy of the artist

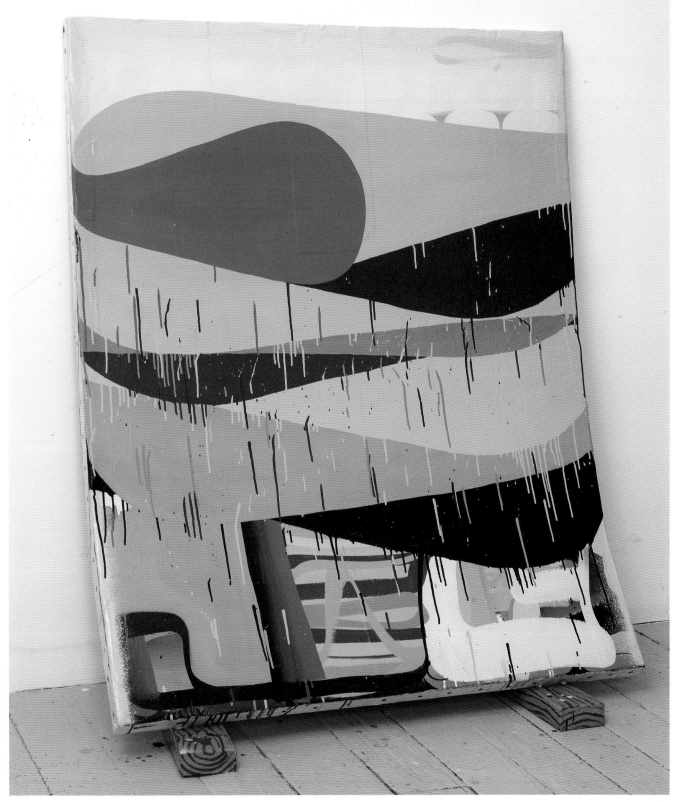

Blocks 2008
Enamel on cardboard, wood, and Variform, 47 × 38 × 22 in.
Courtesy of the artist

Urban Organic 2008
Enamel on cardboard, wood, and Variform, 56 × 37 × 15 in.
Courtesy of the artist

Gum Spirits 2008
Enamel on cardboard, wood, and Variform, 13 × 14 × 7 in.
Courtesy of the artist

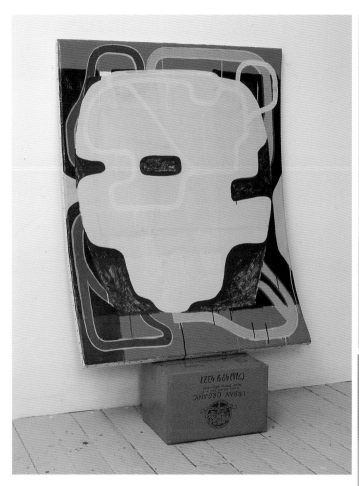

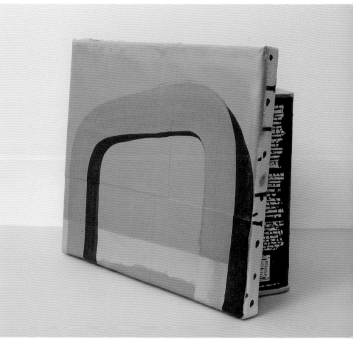

One Shot Box 2008
Enamel on cardboard, wood, and Variform, 19 × 19 × 24 in.
Courtesy of the artist

Kunztruk 2008
Enamel on cardboard, wood and, Variform, 67 × 49 × 21 in.
Courtesy of the artist

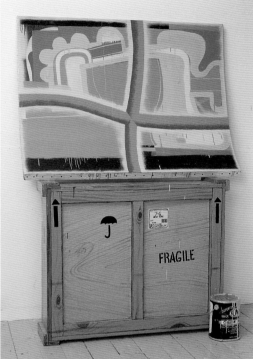

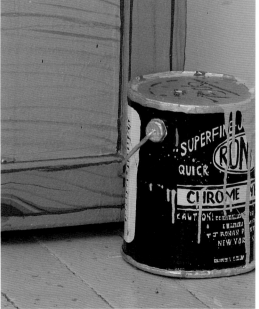

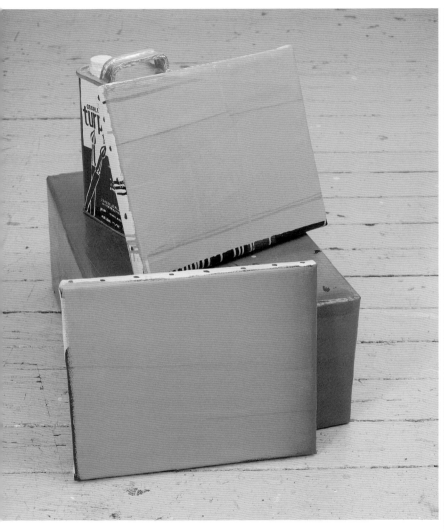

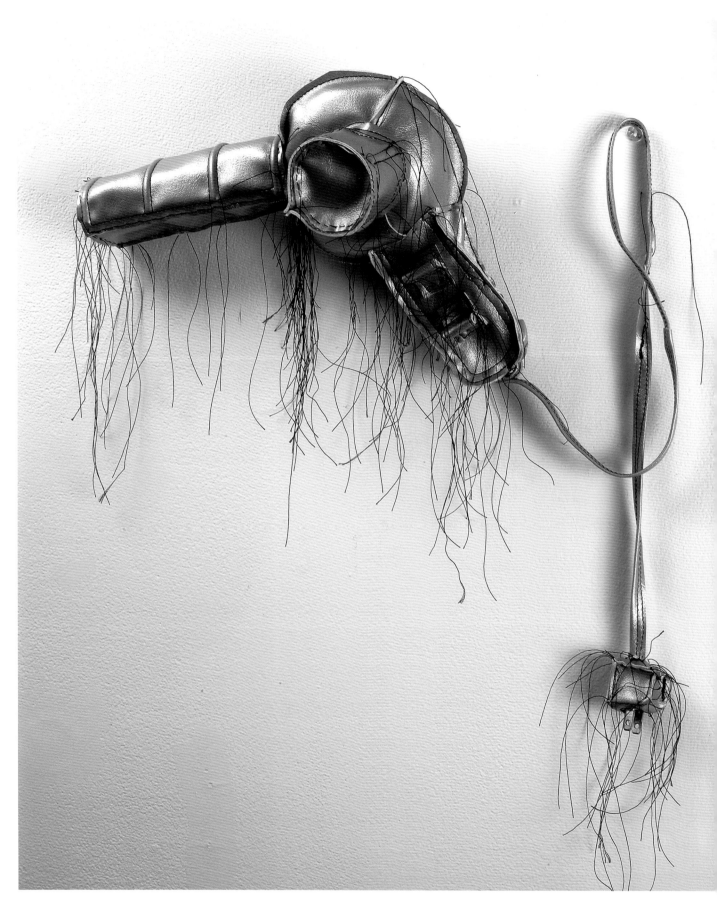

MARGARITA CABRERA's

sculptures synthesize elements of Pop art, folk art, and craft traditions to comment on the complex relationship between Mexico and the United States, especially as it manifests itself at the border. Using a wide range of commonplace and domestic subjects, such as vehicles, kitchen appliances, and the landscape, Cabrera realizes her creations in vinyl, fabric, thread, and, more recently, clay. The combination of familiar subjects and ordinary materials allows easy access to this art, expanding and diversifying Cabrera's audience and drawing attention to social and political issues through symbol and metaphor.

Timesaving and laborsaving household appliances, often assembled in Mexico and sold to Americans, are replicated as soft sculptures. Cabrera's soft Crock-Pots, hair dryers, and waffle makers incorporate actual parts from the original products, but only those parts made in the United States. The Mexican-made parts are refabricated in the studio as visibly handmade and nonfunctional. Brought together in the sculptures, the two components collide, as do the cultures of Mexican workers toiling hard and long while American consumers benefit from this labor. Other soft sculptures replicate items such as a full-scale Hummer, a bicycle, and a Volkswagen Beetle. In the border project *Space in Between*, Cabrera recasts the uniforms of U.S. Border Patrol agents as cacti, ubiquitous plants in the border regions.

More recent clay works depict similar subjects: a full-scale tractor, a wheelbarrow, a ladder. Soft and pliable in its working state, clay in the resulting sculptures is rigid and fixed, in sharp contrast to the fabric works. Cabrera links her use of clay to the ceramic productions of Mexico's pre-Hispanic Olmec civilization, instantly connecting past and present.

In Margarita Cabrera's art, poetry and symbolism merge with social consciousness and politics. The resulting sculptures not only transcend their humble origins to give immense visual pleasure, but they also inform and enlighten in the process.

Margarita Cabrera was born in 1973 in Monterrey, Mexico, and raised in Mexico City. At age twelve, she moved with her family to Salt Lake City, Utah; the family relocated to El Paso, Texas, when she was a teenager. Cabrera earned a Bachelor of Fine Arts in sculpture from Hunter College of the City University of New York in 1997, followed by a Master of Fine Arts from the same institution in 2001. She returned to El Paso after completing her graduate studies.

[page 48]
Pink Blow Dryer 2005
Vinyl, thread, and appliance part, 12 × 4½ × 4 in.
Courtesy of the artist and Sara Meltzer Gallery, New York, New York, and Walter Maciel Gallery, Los Angeles, California

Slow Cooker 2003
Vinyl, thread, and appliance parts, 14 × 10 × 8 in.
Courtesy of the artist and Sara Meltzer Gallery, New York, New York, and Walter Maciel Gallery, Los Angeles, California

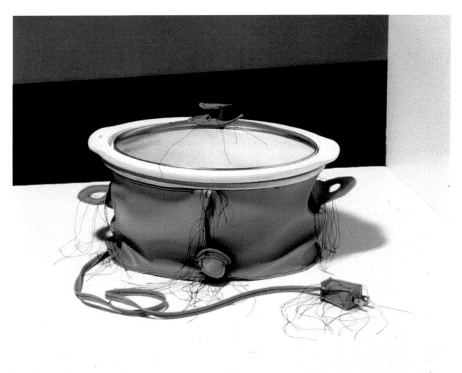

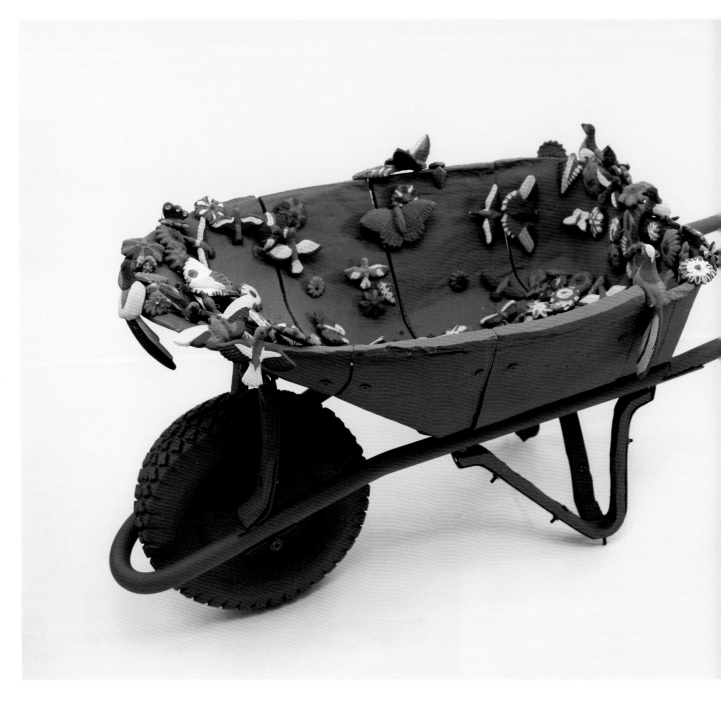

Arbol de la Vida (Carrucha/Wheelbarrow) 2007
Clay, slip paint, and metal hardware, 25 × 60 × 24 in.
Courtesy of the artist and Sara Meltzer Gallery, New York,
New York, and Walter Maciel Gallery, Los Angeles,
California

[page 51]
Arbol de la Vida (John Deere Model #790) 2007
Clay, slip paint, and metal hardware, 85 × 98 × 59 in.
Courtesy of the artist and Sara Meltzer Gallery, New York,
New York, and Walter Maciel Gallery, Los Angeles,
California

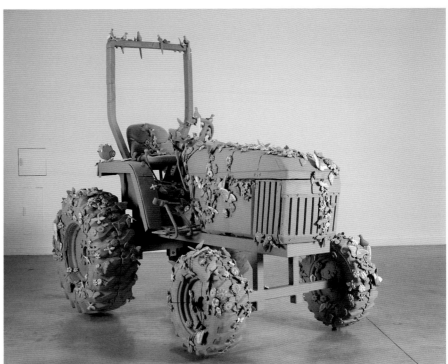

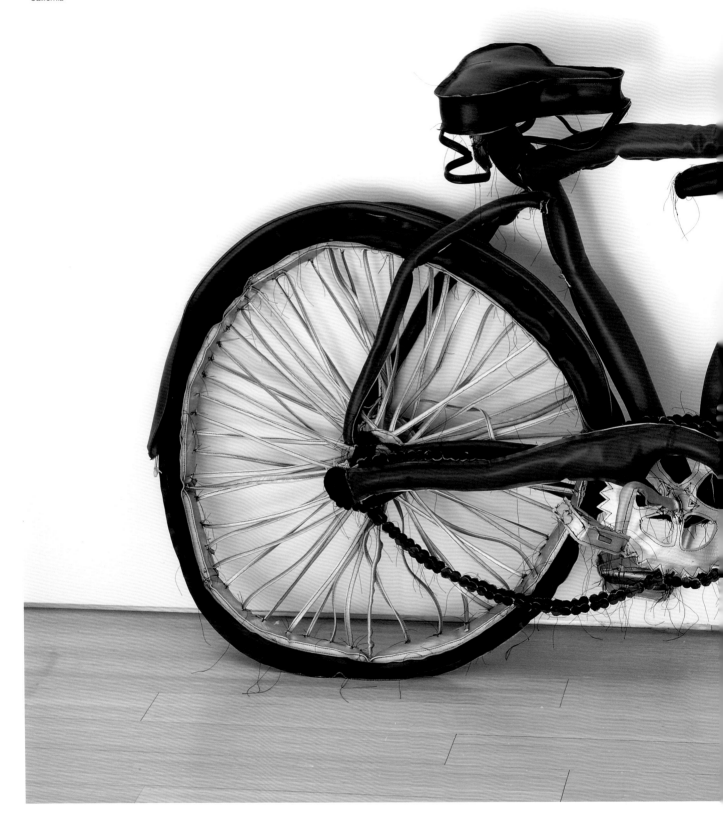

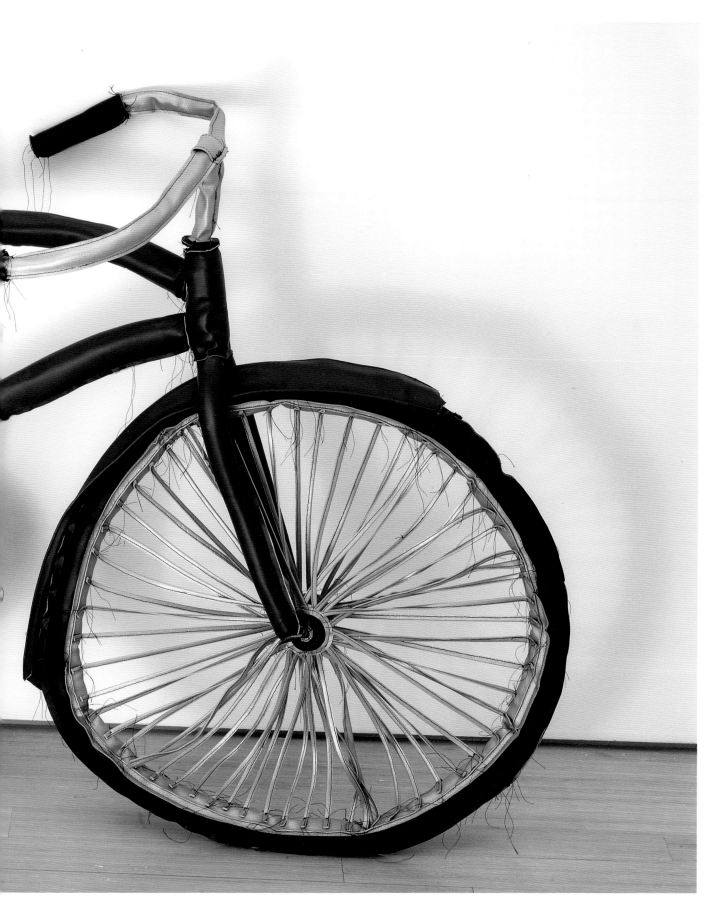

Hummer 2006
Vinyl, thread, fiberglass, metal, and car parts,
84 × 180 × 96 in.
Courtesy of the artist and Sara Meltzer Gallery, New York,
New York, and Walter Maciel Gallery, Los Angeles,
California

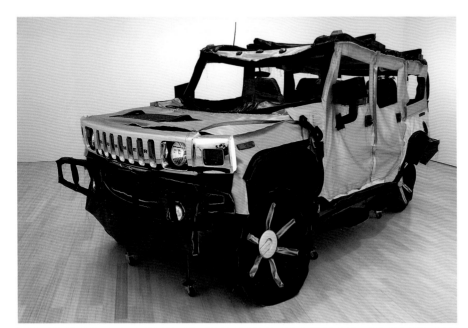

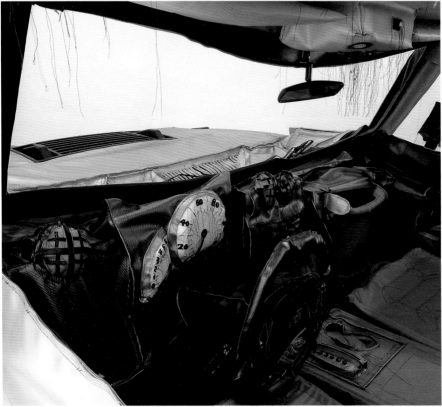

Blue Vocho 2004
Vinyl, thread, fiberglass, metal, and car parts,
60 × 156 × 72 in.
Courtesy of the artist and Sara Meltzer Gallery, New York,
New York, and Walter Maciel Gallery, Los Angeles,
California

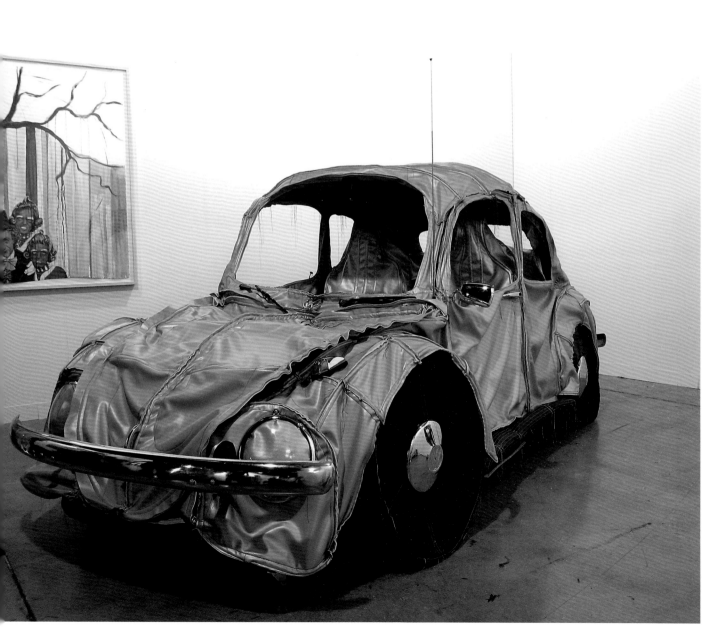

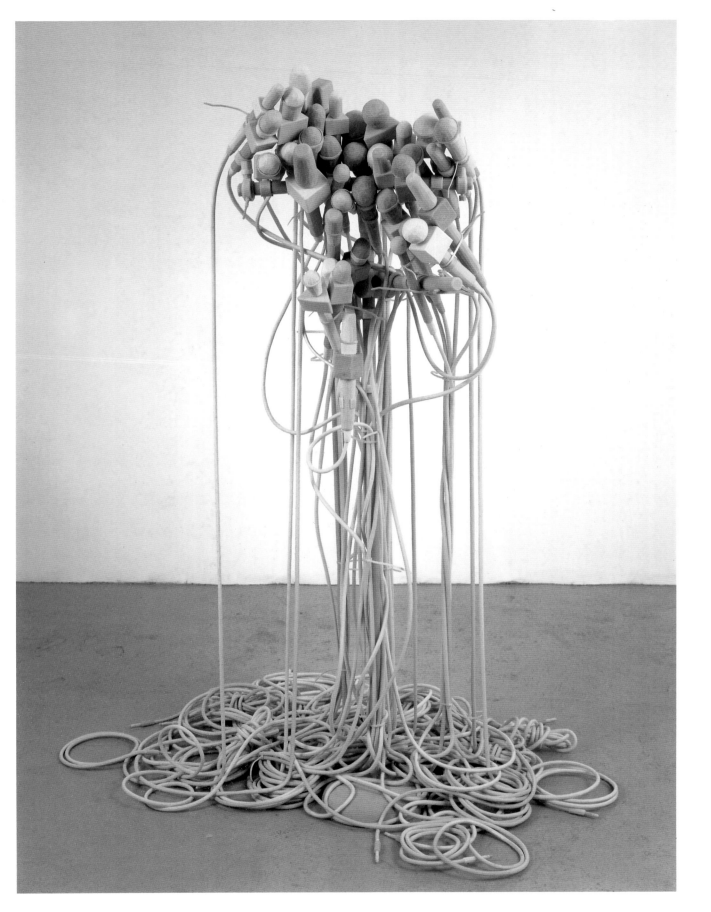

CHRIS HANSON and HENDRIKA SONNENBERG

, working as a collaborative team, fabricate objects, create drawings, make photographs, and produce films and videos. Many of their sculptural works from the past decade, meticulously carved from polystyrene foam, belie their handcrafted origins and seem to be industrially made. The duality of handmade production and machine-produced appearance is a driving force in the team's art, and the objects that result from their labor-intensive practice transcend the material's humble commercial and industrial purposes.

Created from light blue and green foam, the works materialize as ghosts of the actual objects they replicate, at times empty, lifeless, lacking energy. Some of these sculpted versions appear damaged, suggesting an unseen narrative, as if something just happened that destroyed the thing. In other cases, the artists' re-created objects elicit a range of interpretations from viewers.

A large chandelier from 2006 is a wiry entanglement of pale, carved foam microphones and cables, not a delicate assemblage suggesting finely cut or faceted crystal. With microphone heads facing in all directions and cables looped around and around, the chandelier becomes a physical manifestation of overheard or recorded audio information, circulating through a network of wires but ultimately reaching a dead end. An earlier, complementary work, *Soapbox* from 2004, is also composed of microphones and cables. Here microphones are ganged together in mass, as if at a press conference, while the twisted, unplugged cables form a spaghetti-like composition on the floor.

Other foam works more closely resemble their sources and straddle the world of trompe l'oeil. Chainlink fence sections, large industrial machines, vehicle tires are among the many everyday objects obsessively replicated by the team. Yet regardless of the subjects they select, or the way they choose to replicate and interpret their choices as sculptures,

Chris Hanson and Hendrika Sonnenberg confound expectations of the ordinary world by presenting it as something quite extraordinary.

The Canadian duo—Hanson from Montreal, born 1964, and Sonnenberg from Toronto, born 1963—received Bachelors of Fine Arts from the Nova Scotia College of Art and Design in Halifax in 1986 and 1987 respectively. Each of them pursued graduate studies in the United States: Hanson received a Master of Fine Arts from the University of Illinois at Chicago in 1996, and Sonnenberg, an MFA from the School of the Art Institute of Chicago in 1995. The two have collaborated for over two decades, producing more than 600 sculptures together. They live and work in Brooklyn, New York.

[page 56]
Soap Box 2004
Polystyrene and hot glue, 63 × 56 × 41 in.
Collection of Robert Speyer

Microphones 2003
Ink on paper and acetate, 11 × 14 in.
Courtesy of the artists

Studio assistant Ben Turner and artist Hendrika Sonnenberg working on **Zamboni Tires** 2005

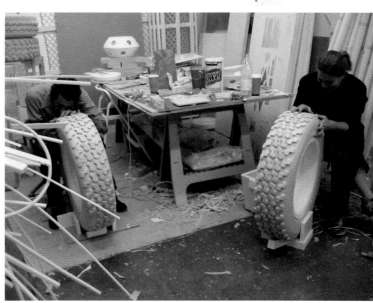

[clockwise from top left]
Chandelier 2006
Polystyrene, hot glue, and painted steel armature,
83 × 54 × 54 in.
Courtesy of the artists and Artist Pension Trust, New York,
New York

Artists' studio, showing **Trash Can** and **Bully** (detail) 2005

Installation in progress, Cohan and Leslie, New York,
New York, 2005

Installation view, Cohan and Leslie, New York, New York,
2004

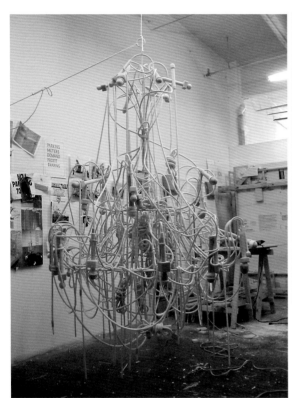

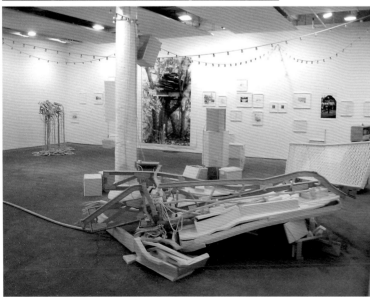

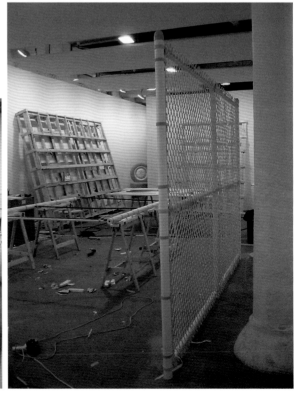

Hot Glue Gun 2005
Ink on paper, 8½ × 11 in.
Courtesy of the artists

Zamboni 2005
Polystyrene, hot glue, and cinder blocks, 76 × 76 × 118 in.
Collection of Tim Nye, New York, New York

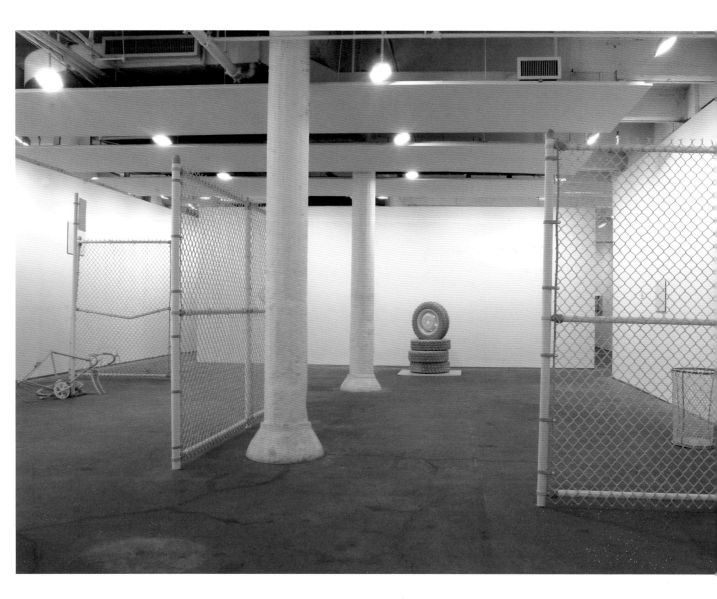

Fence 2005
Polystyrene and hot glue, 96 × 144 × 4 in.
Private collection

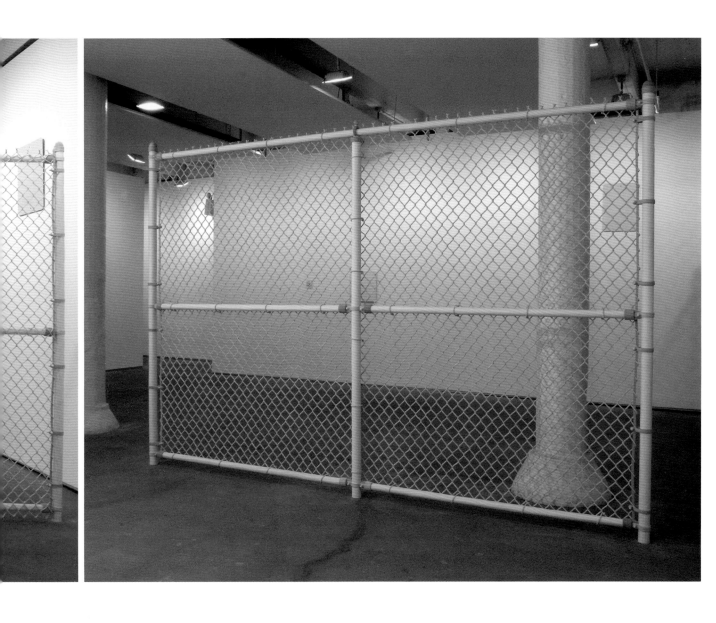

Bully 2004
Polystyrene and hot glue, 108 × 60 × 30 in.
Collection of Art Gallery of Nova Scotia, Halifax, Canada

Half Stack 2004
Polystyrene and hot glue, 48 × 29½ × 8½ in.
Collection of Tim Nye

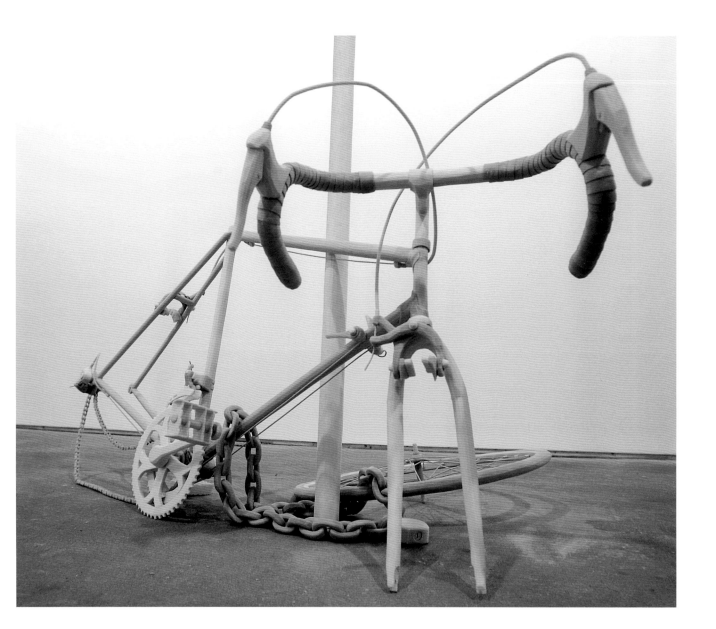

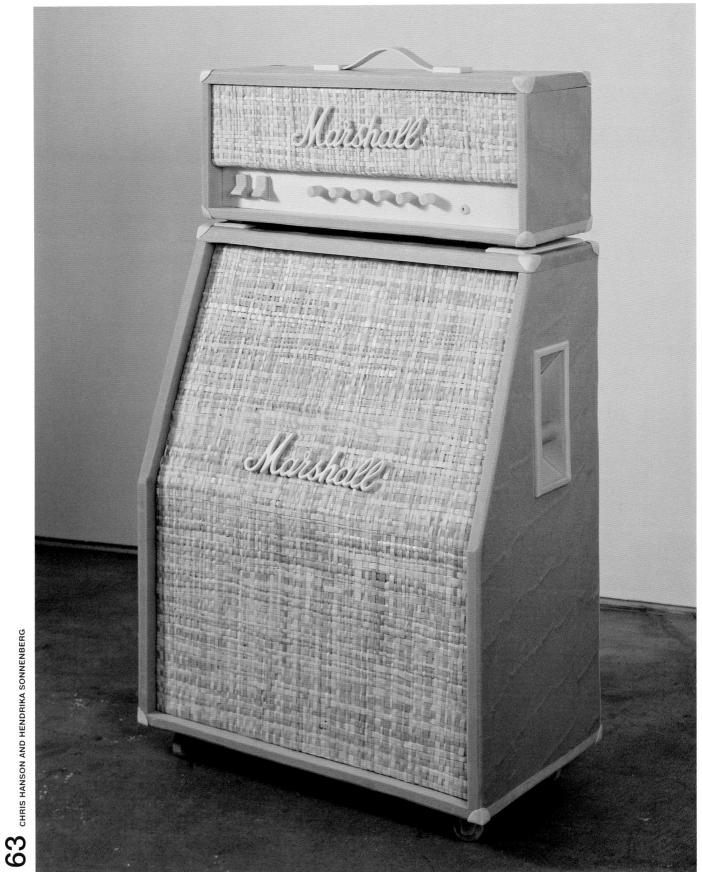

 CHRIS HANSON AND HENDRIKA SONNENBERG

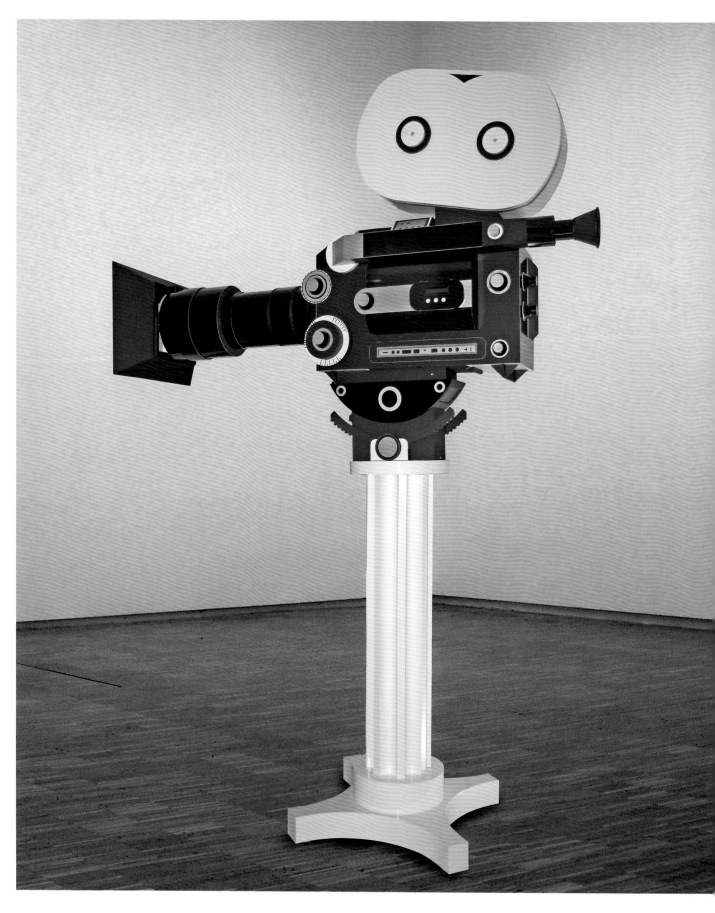

A high level of finish distinguishes

DENNIS HARPER's art.

Whether drawing from real world sources or inventing pure fantasies, Harper fabricates sculptures and installations primarily from sheets of foam board, cardboard, wood, paper, paint, and the like. He skillfully transforms these materials into real-world objects, including a larger-than-life-size motorcycle and a concert grand piano. His fantasy machine, with no function except in the artist's imagination, is so convincing in detail that it surely must exist in life. At times Harper's works incorporate video or audio components, which extend the concepts and imagery in directions beyond that of static object or passive tableau.

An intriguing element in Harper's recent work is his interest in Egyptian imagery and sculptural forms. Motifs from ancient Egypt decorate some of his sculptures, as do combinations of Egyptian and contemporary forms to create eccentric hybrids of the old and new. Harper's art also exhibits connections to 1960s California art generally referred to as the Finish Fetish movement. Artists such as Larry Bell, Craig Kauffman, and John McCracken produced works with the sleek forms and cool finishes associated with California's

car and surf cultures. In his convincing replications and fantastic fabrications, Dennis Harper straddles reality and illusion. Ultimately, his art invites discussions about authenticity and what defines a thing as real.

Dennis Harper began to create his highly detailed and meticulously crafted sculptures and installations after decades of pursuing other endeavors. Born in 1947 in Waco, Texas, Harper spent his childhood in Southern California where his family had resettled during the 1950s. Harper worked as a graphic artist and illustrator, pursued several retail ventures, among other things, and then earned a Bachelor of Fine Arts from the University of Texas at Austin in 2004. In 2009 he received a Master of Fine Arts from the University of Houston, Texas. No doubt Harper's other career paths and range of life experiences contribute significantly to his artistic vocabulary and approach to art making, offering him deep visual and technical resources on which to draw. Harper is based in Austin, Texas.

[page 64]
Super Mega Colossus 2010
Foam board, paper, and wood, 116 × 37 × 80 in.
Courtesy of the artist

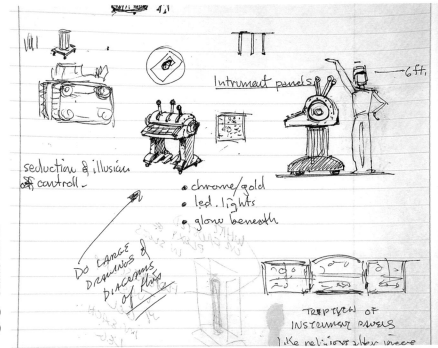

Artist's notebook 2006
Courtesy of the artist

Artist's sketchbook 2006
Courtesy of the artist

Cheap Ass Boom Box in a Deluxe Console 2007
Paper, foam board, wood, lights, PVC, boom box
components, and audio, 60 × 60 × 48 in.
Courtesy of the artist

Super Mega Colossus (detail) 2010
Foam board, paper, and wood, 116 × 37 × 80 in.
Courtesy of the artist

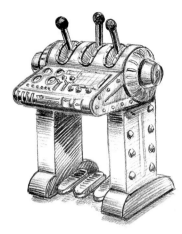

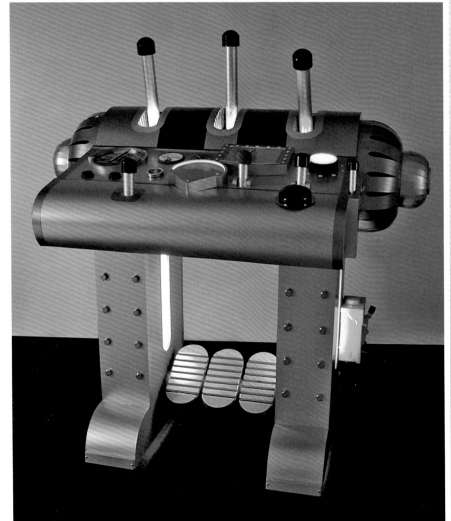

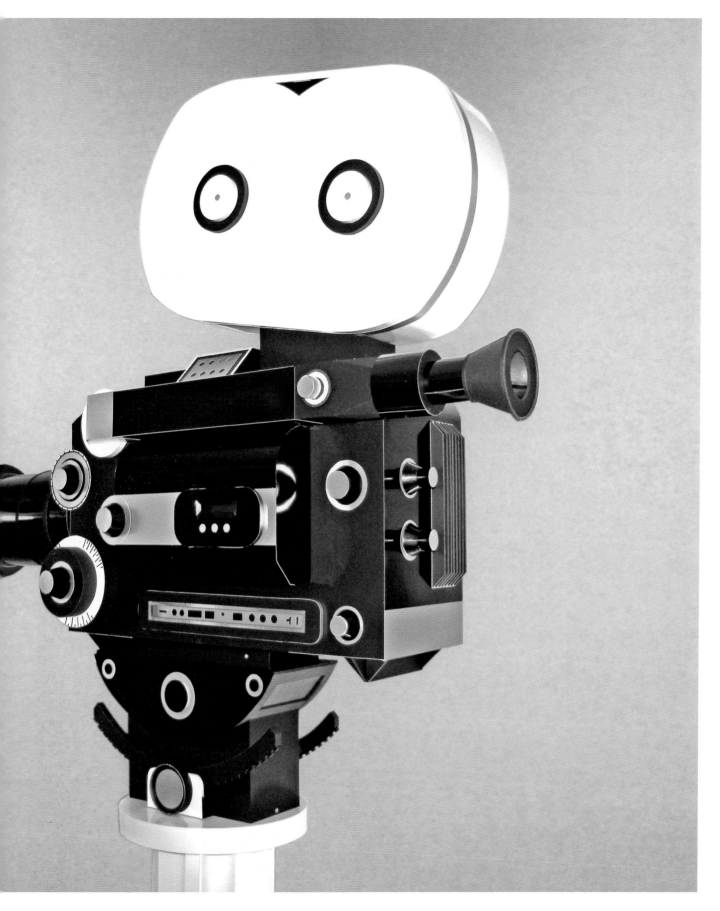

Ritual Prototypes for the Afterlife (detail) 2009
Foam board, paper, fabric, wood, and PVC,
dimensions variable
Courtesy of the artist

Ritual Prototypes for the Afterlife (detail) 2009
Foam board, paper, fabric, wood, and PVC,
dimensions variable
Courtesy of the artist

Paper Motorcycle 2004
Foam board, paper, wood, and PVC, 69 × 54 × 132 in.
Courtesy of the artist

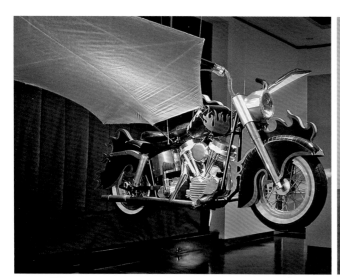

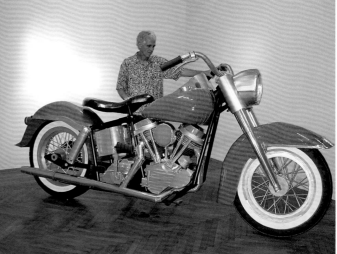

American Idol 2007
Foam board, paper, PVC, and paint, 60 × 54 × 144 in.
Courtesy of the artist

Skate 2006
Wood, trucks, gold leaf, grip tape, and paint, 15 × 8 × 36 in.
Collection of Kevin J. Madden

Throne 2009
La-Z-Boy recliner, wood, fabric, gold leaf, and paint,
60 × 38 × 55 in.
Courtesy of the artist

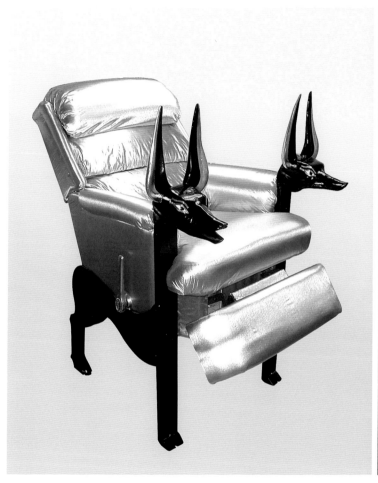 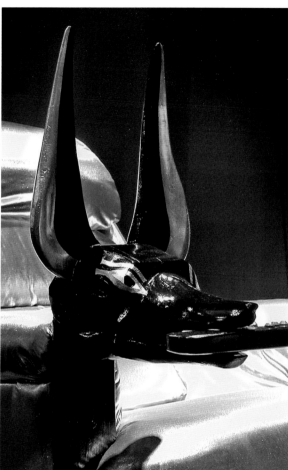

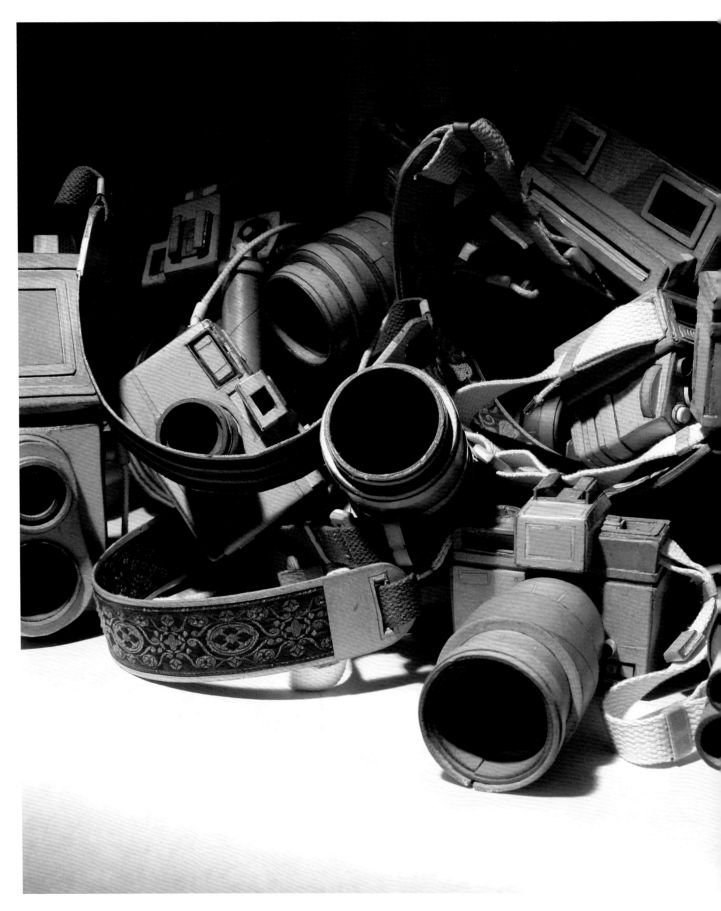

From **KIEL JOHNSON**'s childhood in suburban Kansas City, Missouri, where his father produced the *Johnson's County Gazette,* the artist developed an interest in mechanical devices. Johnson's skillfully hand-built replications of boom boxes, cassette tapes, cameras, and microphones, among other subjects, pay nostalgic homage to antiquated and disappearing technologies. Generally made with cardboard, particleboard, glue, and tape, the sculptures are monochromatic and their scale is greatly altered from the real objects on which they are based. In addition to making sculpture, Johnson creates exquisite, highly detailed black-and-white drawings. These two media—sculpture and drawing—come together in a full-scale printing press sculpture from 2009. The press, titled *Publish or Perish,* appears to produce printed versions of one of the artist's large, obsessive drawings. *Publish or Perish* connects Johnson's youth in Missouri with his current interest in outmoded technologies attempting to survive in the digital era.

In another work from 2009, *Twin Lens Reflex Camera,* Johnson fashioned an oversize yet fully functional camera. He uses the camera to make odd photographs that he exhibits alongside his three-dimensional works. In a different group of sculptures, Johnson reproduces still and movie cameras of various types, such as 35mm and Polaroid, many complete with vintage-looking shoulder straps. Simulated boom boxes, microphones, cassette tapes, and other sculptures reinforce the artist's interest in methods for recording and transmitting information in both audio and visual form, an interest that he makes tangible in these nonfunctional sculptures. Additionally, Johnson extends symbolic and metaphorical aspects of his art by inventing devices that borrow elements from real sources yet are entirely fictional, despite being convincingly fabricated.

Like his sculpture, Johnson's finely rendered, monochromatic drawings depict both real objects and invented ones. A visual inventory of the artist's possessions, *Everything I Own* spreads across the page in patchwork fashion. The drawing is printed over and over on a large roll of paper threaded through the rollers of the ersatz printing press. Derived from Johnson's original drawing, these mass-produced prints are a counterpoint to the artist's unique sculptures based on manufactured consumer products.

Kiel Johnson was born in Kansas City, Missouri, in 1975, and studied sculpture and drawing at the University of Kansas in Lawrence, where he received a Bachelor of Fine Arts in 1998. He obtained a Master of Fine Arts from California State University, Long Beach, in 2000. He remains on the West Coast, in a workspace in Los Angeles called Hyperbole Studios.

[page 72]
Shoot Out (detail) 2009
Chipboard, tape, glue, and acrylic sealer, dimensions variable
Courtesy of the artist and Davidson Contemporary, New York, New York

Twin Lens Reflex 2009
Chipboard, tape, glue, and acrylic sealer, 20 × 16 × 36 in.
Courtesy of the artist and Mark Moore Gallery, Santa Monica, California

Kiel Johnson grinding welds on **Publish or Perish** 2009

[pages 74–75]
Everything I Own (detail) 2009
Ink on paper, 36 × 55 in.
Courtesy of the artist and Mark Moore Gallery, Santa Monica, California

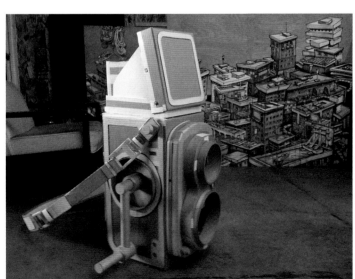

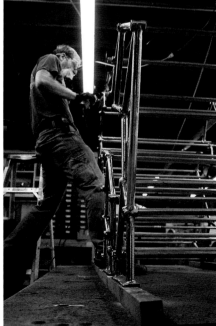

It Was a Quiet Day Today 2009
Ink on paper, 48 × 60 in.
Courtesy of the artist and Mark Moore Gallery,
Santa Monica, California

SLR#4 2009
Chipboard, tape, glue, and acrylic sealer,
dimensions variable
Courtesy of the artist and Davidson Contemporary,
New York, New York

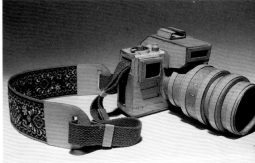

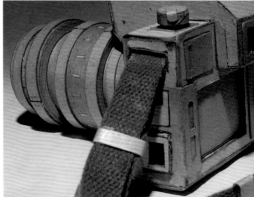

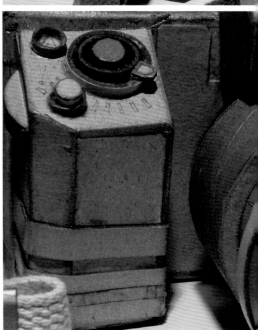

Pack It Up, Let's Go . . . 2008
Pine, Masonite, chipboard, tape, glue, and acrylic sealer,
36 × 20 × 16 in.
Courtesy of the artist and Mark Moore Gallery,
Santa Monica, California

Boom-Boom 2009
Chipboard, cardboard, tape, glue, and acrylic sealer,
36 × 16 × 10 in.
Courtesy of the artist and Davidson Contemporary,
New York, New York

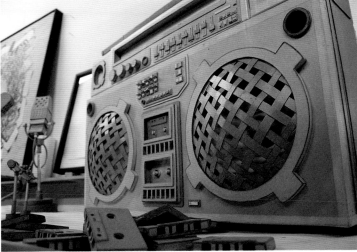

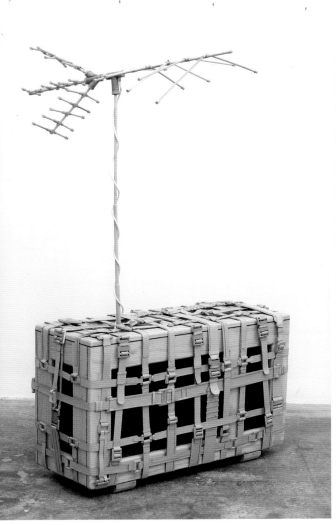

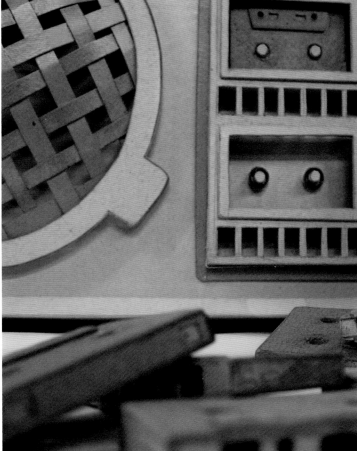

KIEL JOHNSON

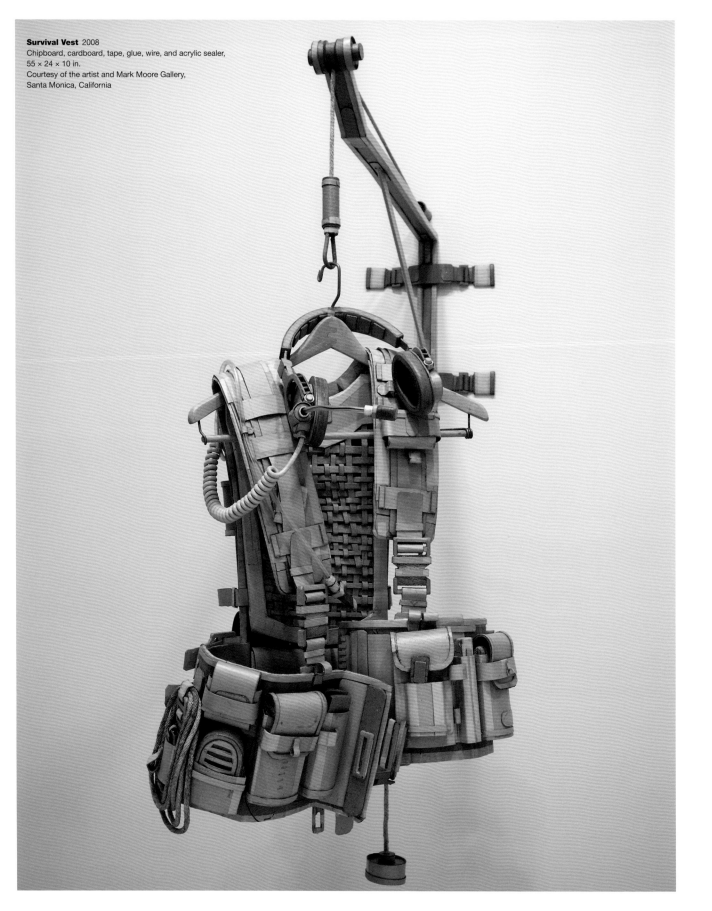

Survival Vest 2008
Chipboard, cardboard, tape, glue, wire, and acrylic sealer,
55 × 24 × 10 in.
Courtesy of the artist and Mark Moore Gallery,
Santa Monica, California

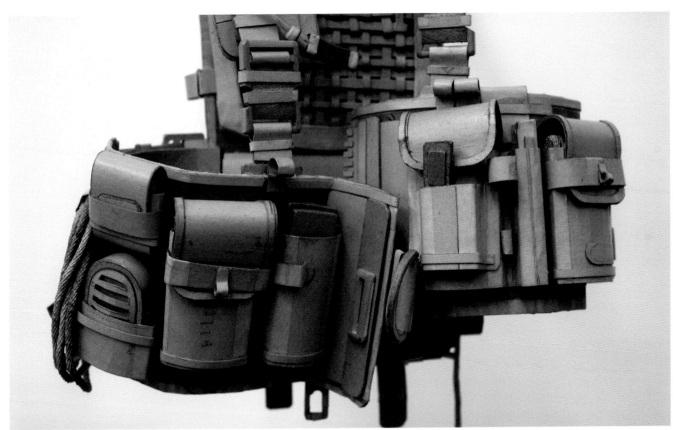

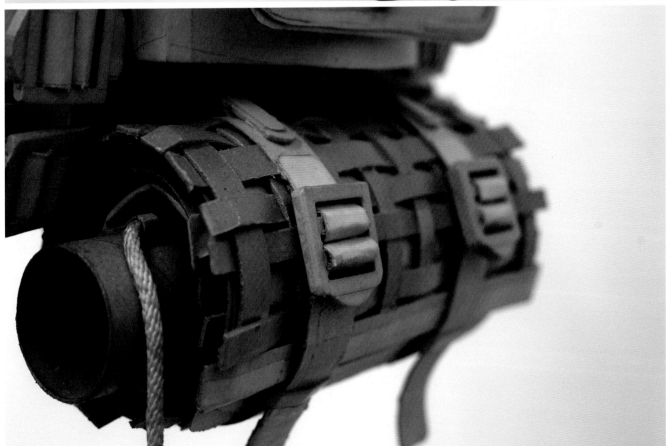

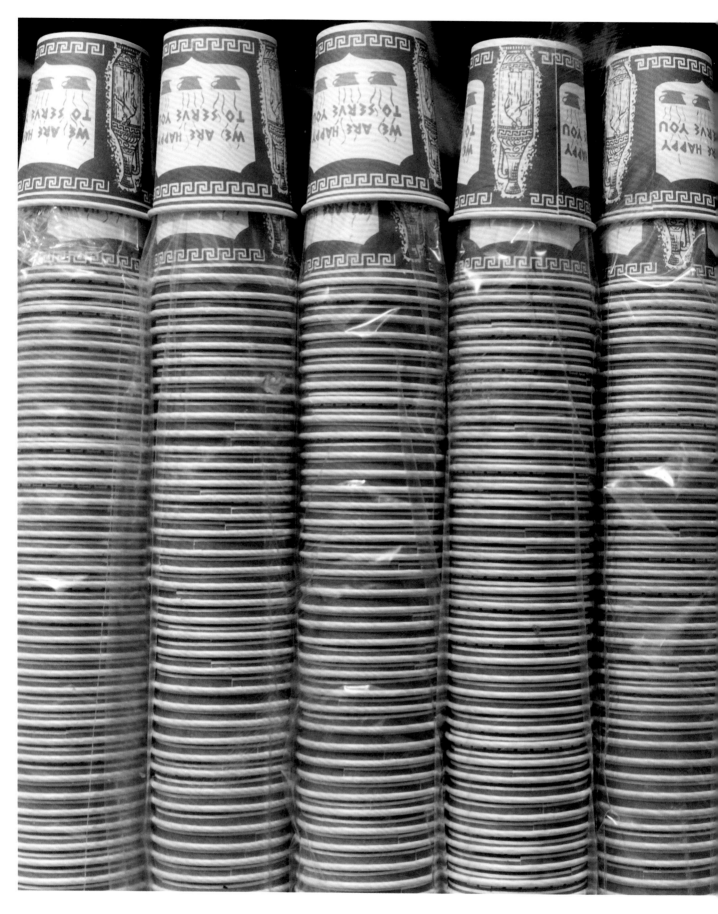

KEVIN LANDERS is interested in everyday urban culture, which he documents in photographs and re-creates in sculpture. Landers's primary art form is photography, and he uses his camera to record detritus and ephemera often unnoticed on city streets. Also an accomplished sculptor, Landers constructs three-dimensional, handmade interpretations of the same subjects that he photographs. Of particular interest to the artist is New York City, especially its ordinary neighborhoods like the East Village, areas not frequented by the wealthy and privileged.

Landers uses simple materials—plastic, wire, and duct tape—to handcraft his unique re-creations of mass-produced objects and consumer products. He works from memory, interpreting as much as replicating: "Not seeing things in front of me kind of forces me to design myself. And it gives my work that hand-drawn aspect, like a bad drawing. I feel like I would lose my hand in it if it were just a copy."[1]

A black briefcase displays glittery watches for sale as on New York's crowded Canal Street. Fashioned from brass, aluminum, and tin, Landers's versions are clearly handmade, lacking the deceptive appearance of the cheap knockoffs they reference. A rack of brightly colored bags of snack chips tantalizes with its rich palette and strong graphic qualities. A vandalized bicycle, missing its seat, handlebars, and front wheel, lies chained to a signpost, abandoned and lifeless. While these commonplace things would not merit a second look when encountered on the street, when fashioned in Landers's studio and presented out of context, removed from their normal surroundings, they appear almost exotic and immediately command attention. Giving value to the ordinary and the unsung, Kevin Landers's urban vignettes cause viewers to question what are appropriate subjects for works of art.

Kevin Landers was born in 1965, in Palmer, Massachusetts. After receiving a Bachelor of Fine Arts from the School of the Art Institute of Chicago, Landers began working as a photographer. He began to exhibit sculpture in the mid-1990s, and sees his photographs and sculptures as completely interrelated. Landers continues to make photographs as his primary art form. His studio is in Brooklyn, New York.

1 Kevin Landers quoted in Kristi Cameron, "Objets d'Art," *Metropolis Magazine*, June 13, 2005, http://www.metropolismag.com/story/20050613/objets-dart (accessed June 29, 2010).

[page 80]
Untitled (Cups) (detail) 1998
C-print, 29⅞ × 44½ in.
Courtesy of the artist and Elizabeth Dee, New York, New York

Untitled (Bottled Water) 2007
Ink and colored marker on paper, 12 × 9 in.
Courtesy of the artist and Elizabeth Dee, New York, New York

Untitled (Thrift Store Appliance Shelf) 2005
Graphite on paper, 11 × 8½ in.
Courtesy of the artist and Elizabeth Dee, New York, New York

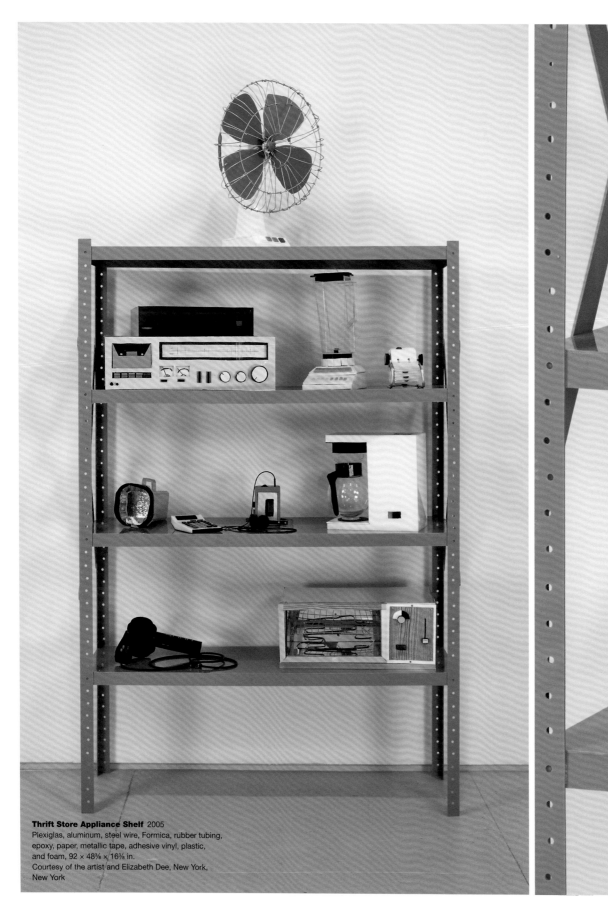

Thrift Store Appliance Shelf 2005
Plexiglas, aluminum, steel wire, Formica, rubber tubing,
epoxy, paper, metallic tape, adhesive vinyl, plastic,
and foam, 92 × 48⅜ × 16⅝ in.
Courtesy of the artist and Elizabeth Dee, New York,
New York

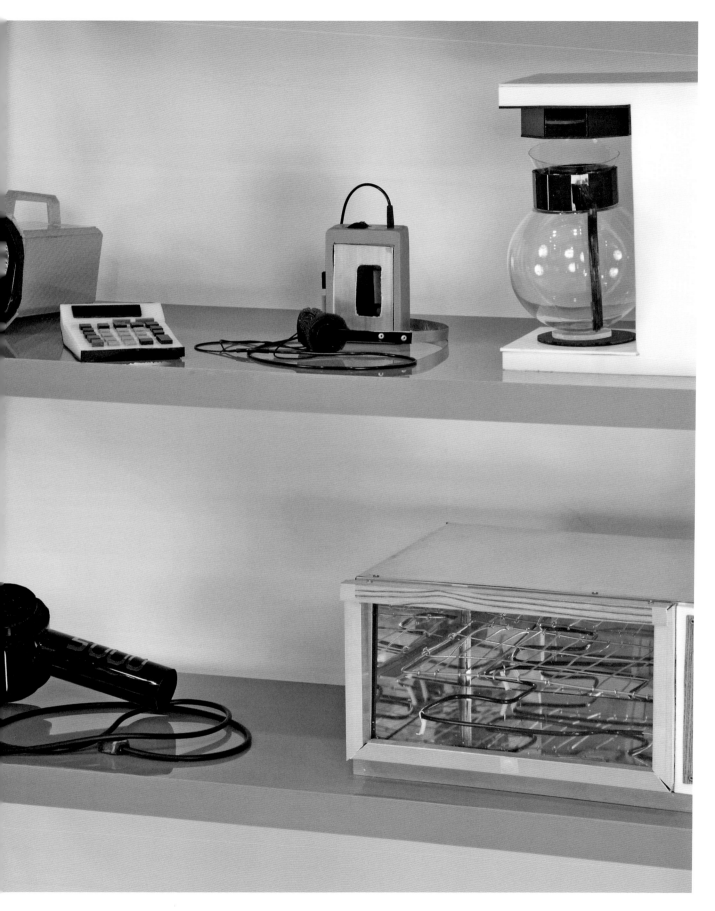

Chip Rack 2005
Wire, electrical conduit, epoxy, polypropylene, vinyl, Mylar, metallic tape, and Styrofoam, 88 × 48½ × 22½ in.
Courtesy of the artist and Elizabeth Dee, New York, New York

Untitled (Grate, New York) 2002
C-print, 29⅞ × 40¼ in.
Courtesy of the artist and Elizabeth Dee, New York, New York

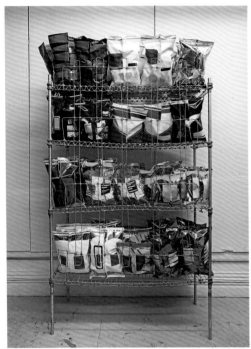

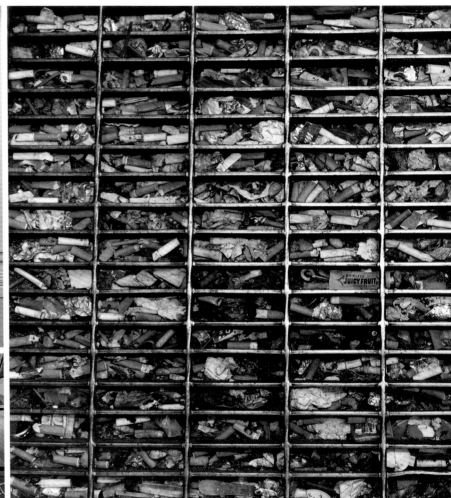

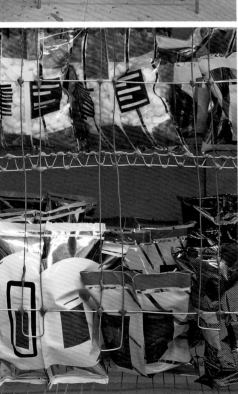

Untitled (Birdcages, Paris) (detail) 2002
C-print, 48⅞ × 29¾ in.
Courtesy of the artist and Elizabeth Dee, New York,
New York

Untitled (Man with Plaid Cart, New York) (detail)
2002
C-print, 47 × 31⅞ in.
Courtesy of the artist and Elizabeth Dee, New York,
New York

Sunglasses Rack 2005
Crayon on paper, 30¾ × 20⅜ in.
Courtesy of the artist and Elizabeth Dee, New York,
New York

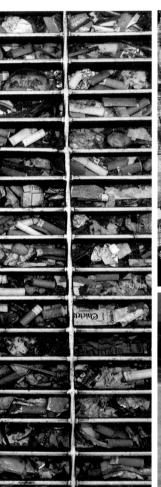

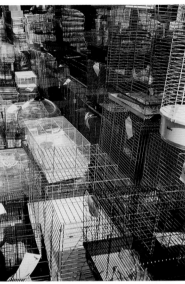

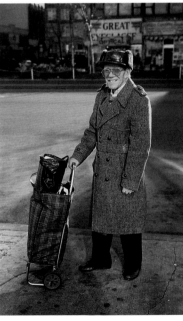

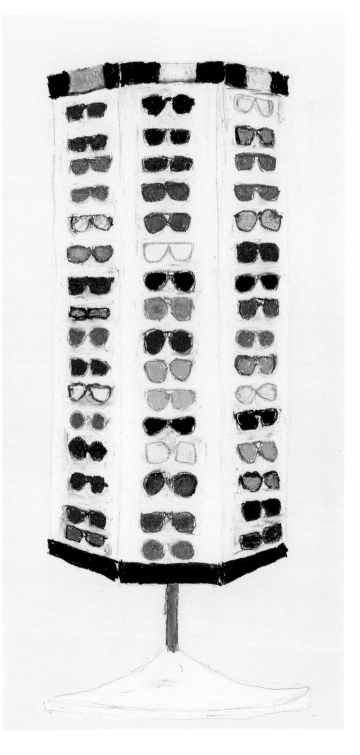

Untitled (Broom Sweeping Sludge, New York)
(detail) 2002
C-print, 23⅛ × 18⅛ in.
Courtesy of the artist and Elizabeth Dee, New York,
New York

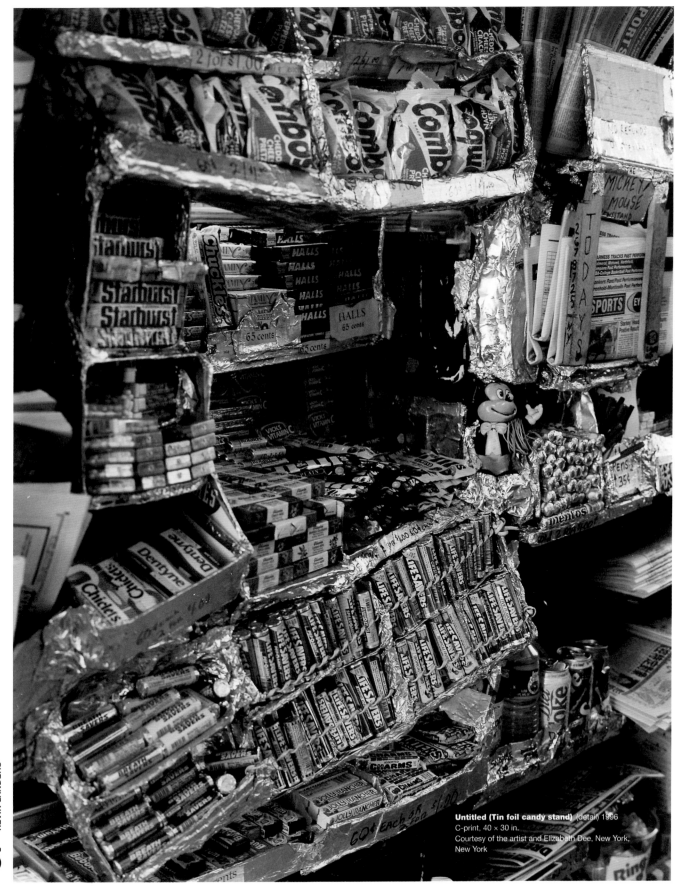

Untitled (Tin foil candy stand) (detail) 1996
C-print, 40 × 30 in.
Courtesy of the artist and Elizabeth Dee, New York,
New York

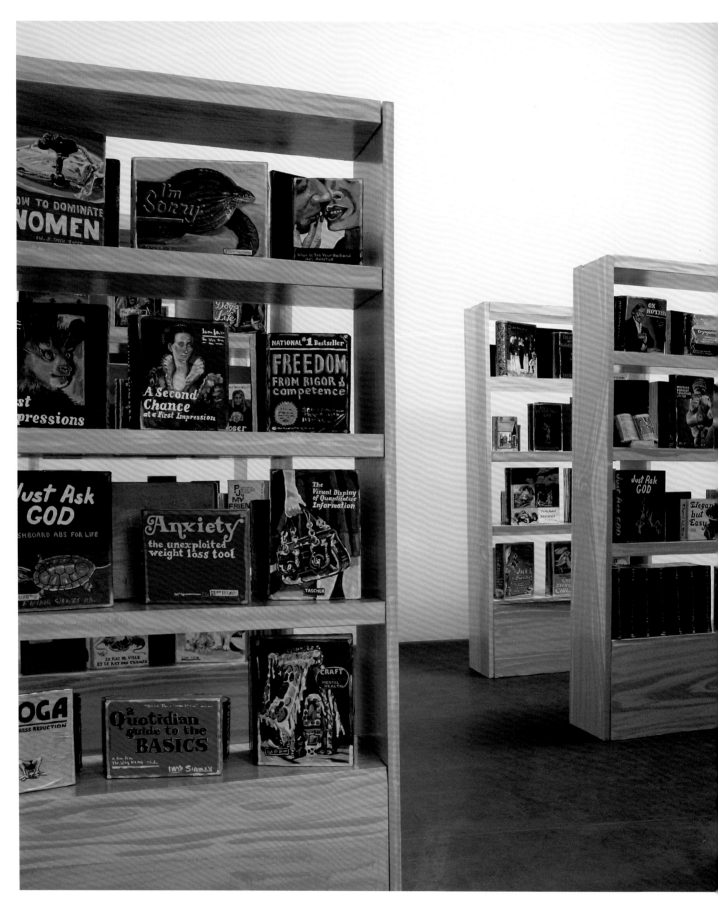

JEAN LOWE's elaborate sculptures and installations combine aspects of the fine and decorative arts to offer witty critiques of contemporary culture. Her interest in high style and period design translates into lavish rococo drawing rooms; offices filled with modern, mid-century furniture; or shelves and shelves of "books" bearing the artist's invented titles and cover illustrations. The surfaces of Lowe's clunky, polychrome sculptures thrive on being handcrafted, constructed from cardboard and papier-mâché and expressively painted in a high-key palette. In Lowe's hands, both mass-produced objects and unique examples bear similarities to the homemade.

A theatrical tableau installation with strong narrative qualities, *The Loneliness Clinic*, complete with a patient waiting room and therapist's office, offers a highly detailed stage for action to take place. In the waiting room are painstaking reconstructions of classic side chairs by architect Marcel Breuer, an artificial "artificial" plant, and wall-hung shelves of magazines—everything one would expect in the real world. The interior office features more high design furniture, a patterned Oriental rug, a wall unit holding large pill bottles, framed certificates, and awards from the Harvard crew team and Stanford chess club. Lowe carefully fashioned each brightly colored element from ephemeral materials, painted to resemble the original.

An equally skilled painter and sculptor, Jean Lowe is also a decorator of the highest order. She is unafraid to approach large projects for both indoors and outdoors. Her period rooms, similar to those found in museums and historic houses, are filled with nonfunctional furniture and replications of classical paintings. Libraries offer shelves of sculptures that mimic books in their look and design. Lowe further extends her world outdoors with the creation of a life-size SUV (sport utility vehicle).

Born in 1960, in Eureka, California, Lowe studied at the University of California, Berkeley, where she earned a Bachelor of Arts in 1983. In 1988 she received a Master of Fine Arts from the University of California, San Diego, in La Jolla. Lowe is married to artist Kim MacConnel, who was associated with the Pattern and Decoration movement of the 1970s. The couple lives in Encinitas, California.

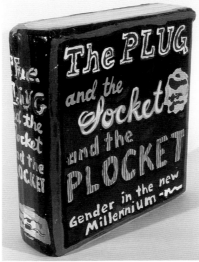

The Plug and the Socket and the Plocket 2003
Enamel on papier-mâché, 10¼ × 11½ × 3¾ in.
Collection of Randi and Eric Sellinger, Courtesy of McKenzie Fine Art Inc., New York, New York

Accomplishments of Man (detail) 1992
Enamel on papier-mâché, enamel on canvas, oil on canvas, etched mirrors, and site specific painting, dimensions variable
Courtesy of the artist and Quint Contemporary Art, La Jolla, California

[page 89]
Achieve and Maintain a More Powerful Delusion
(detail) 2007
Enamel on papier-mâché and cardboard, dimensions variable
Courtesy of Rosamund Felsen Gallery, Santa Monica, California, and McKenzie Fine Art Inc., New York, New York

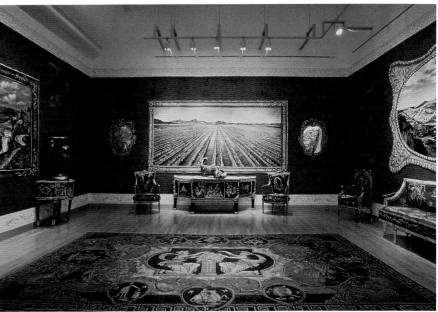

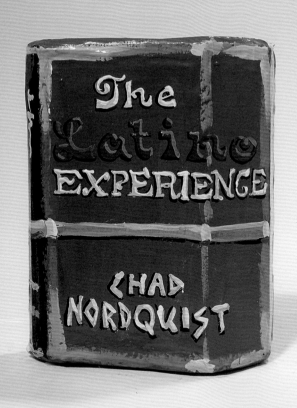

The Latino
EXPERIENCE

CHAD
NORDQUIST

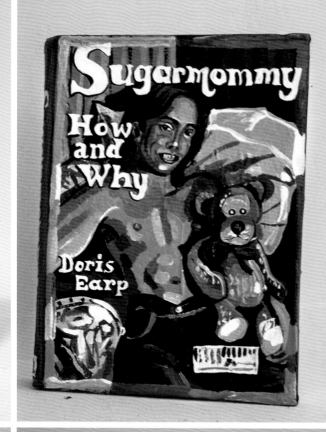

Sugarmommy

How
and
Why

Doris
Earp

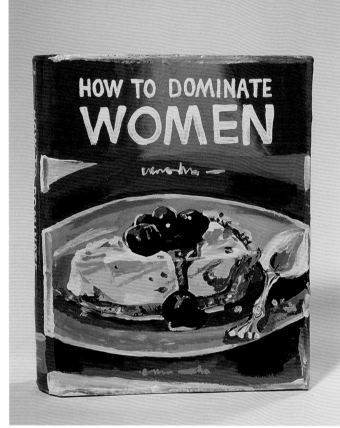

HOW TO DOMINATE
WOMEN

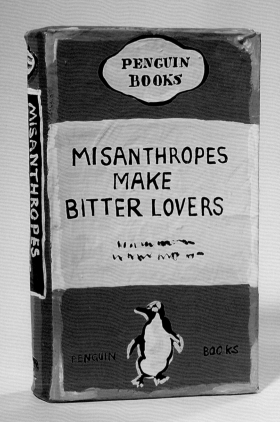

PENGUIN
BOOKS

MISANTHROPES

MISANTHROPES
MAKE
BITTER LOVERS

PENGUIN BOOKS

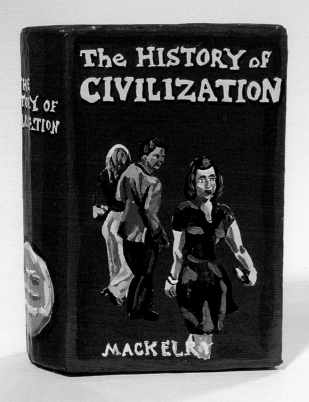

The HISTORY of CIVILIZATION

MACKELRY

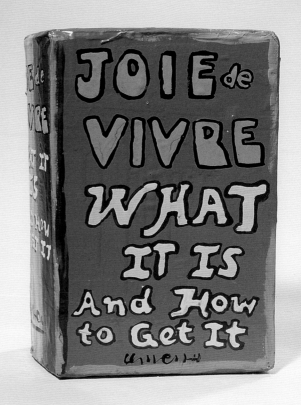

JOIE de VIVRE WHAT IT IS And How to Get It

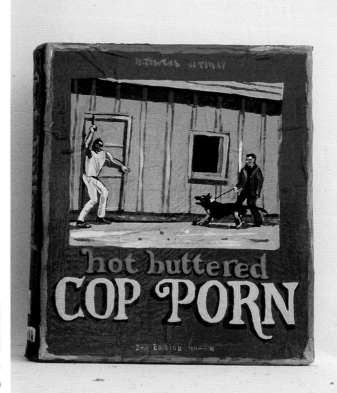

hot buttered COP PORN

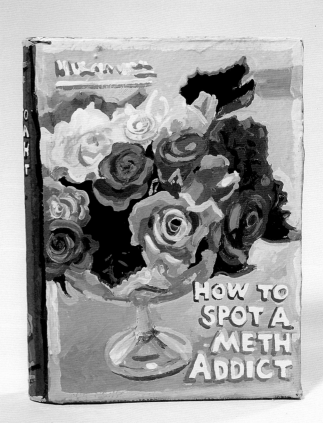

HOW TO SPOT A METH ADDICT

Blackout Drinker (Doctor's Notes) 2004
Enamel on papier-mâché, 13⅛ × 10½ in.
Collection of David Ross

Unbelievable Banality (Doctor's Notes) 2004
Enamel on papier-mâché, 13⅛ × 10½ in.
Collection of Nicoli and Brian Tucker

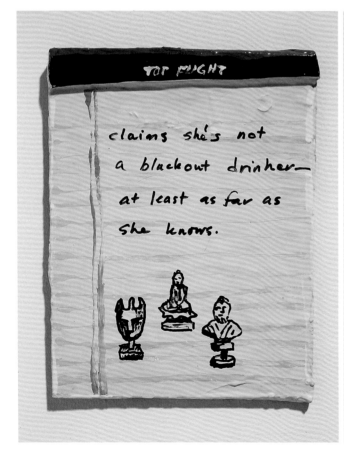

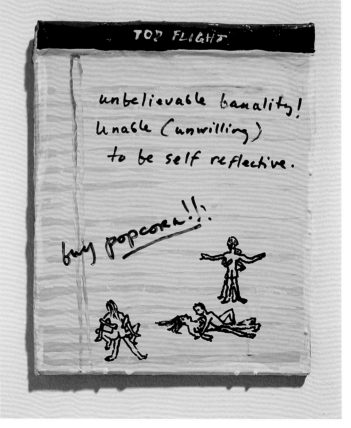

The Loneliness Clinic (details) 2004
Enamel on papier-mâché and enamel on canvas,
dimensions variable
Courtesy of Rosamund Felsen Gallery, Santa Monica,
California, and McKenzie Fine Art Inc., New York, New York

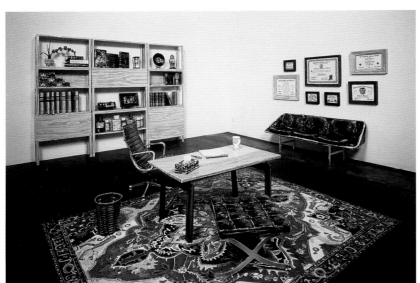

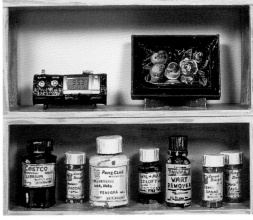

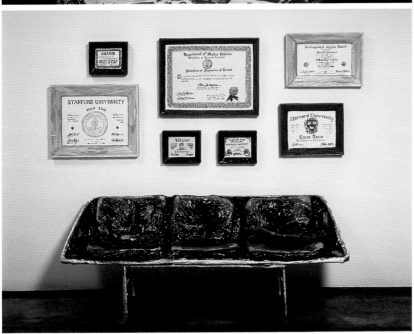

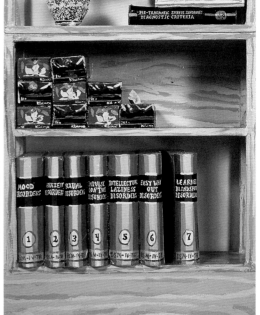

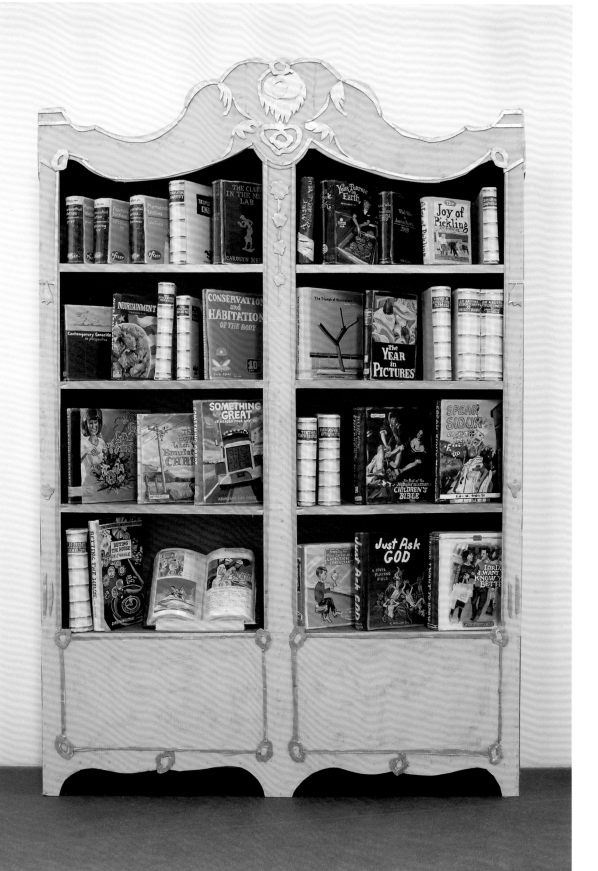

Cloister Bookshelf—Double 2009
House paint on cardboard, wood, and enamel on
papier-mâché, 108 × 72¾ × 12¾ in.
Courtesy of Rosamund Felsen Gallery, Santa Monica,
California

Gastronomique—Yellow Chinese Chicken 2002
Enamel and resin on papier-mâché, 13½ × 13½ × 1½ in.
Collection of Joyce and Ted Strauss

Gastronomique—Pink Pig 2002
Enamel and resin on papier-mâché, 13½ × 13½ × 1½ in.
Collection of Joyce and Ted Strauss

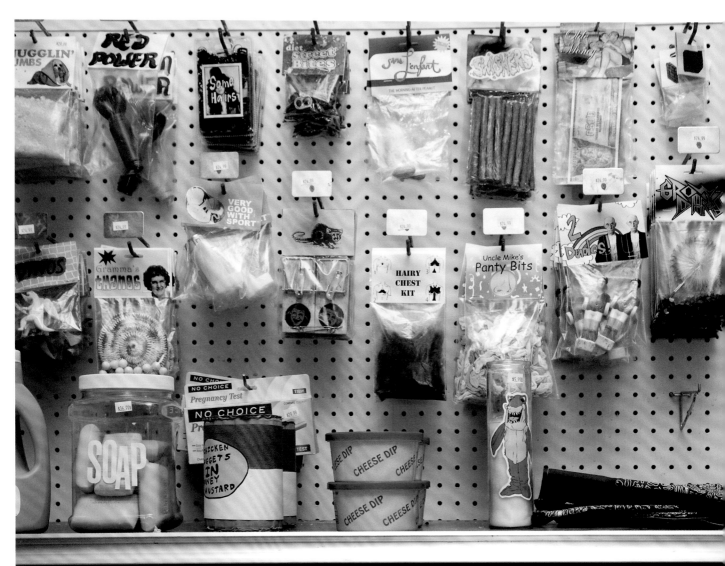

OKAY MOUNTAIN collective assembles the vision and talents of ten artists: Sterling Allen, Tim Brown, Peat Duggins, Justin Goldwater, Nathan Green, Ryan Hennessee, Josh Rios, Carlos Rosales-Silva, Michael Sieben, and Corkey Sinks. Formed in 2006 and based out of Austin, Texas, the collective consists of members spread across the country and work both individually as well as in collaboration. The members joined forces while operating the Austin artists-run space Okay Mountain. Taking the form of large installations, environments, and murals, works by Okay Mountain stress group efforts over individual style, hand-made production over slick fabrication, and active audience engagement over passive viewing.

The collective's 2009 participatory environment *Corner Store* critiques the global phenomenon of the commercial art fair—the very institution for which it was created and presented. *Corner Store* appeared in Florida at PULSE Miami to great acclaim, winning the fair's prize for best emerging artist. A fully operational retail store, *Corner Store* mimicked convenience stores ubiquitous across America if not the world. The collective created a structure in which the visitor could select from a huge range of hand-made items, all available to purchase, all made by members of the collective, and with numerous objects made as multiples in order to keep a well-stocked inventory. Collectors purchased parts of the *Corner Store* installation, as they did other works at the fair, along with products on the store's shelves and racks.

Stylistically the collective's productions incorporate a wide range of elements including found and fabricated images, graphics, three-dimensional objects, and media components such as audio and video. Handmade objects are created from everyday materials such as card-board, Styrofoam, tape, and wood, and clearly show evidence that each is unique, even when made as multiples. With their slap-dash techniques and humorous references to consumer culture and advertising, the collective's works

contrast sharply with the cool distance found in other commodity-based work by artists such as Barbara Kruger and Haim Steinbach, whose legacies the collective inherits.

While each contributor offers a distinct voice to the collective, the resulting vision is a unified whole, ener-gized through a synthesis of individual interest, ability, and approach. Introduction of an audience further completes this wholeness, especially in cases where the art is functionally interactive, as in *Corner Store*. For Okay Mountain collective, the cooperative spirit extends from artist to art to audience.

[page 96]
Corner Store (detail) 2009
Mixed media installation, dimensions variable
Courtesy of the artists

Corner Store (detail) 2009
Mixed media installation, dimensions variable
Courtesy of the artists

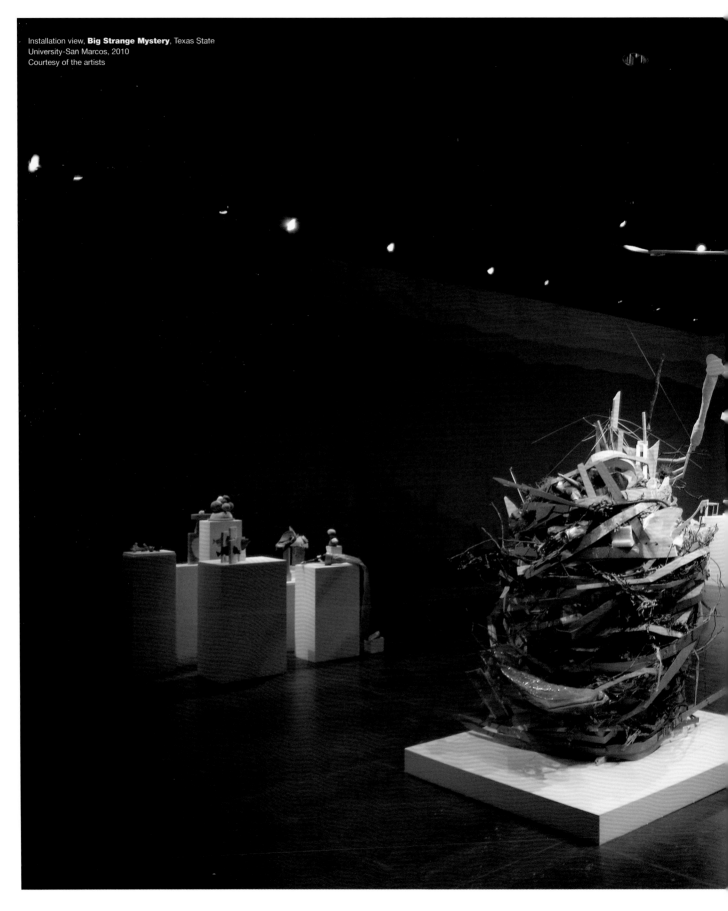

Installation view, **Big Strange Mystery**, Texas State
University-San Marcos, 2010
Courtesy of the artists

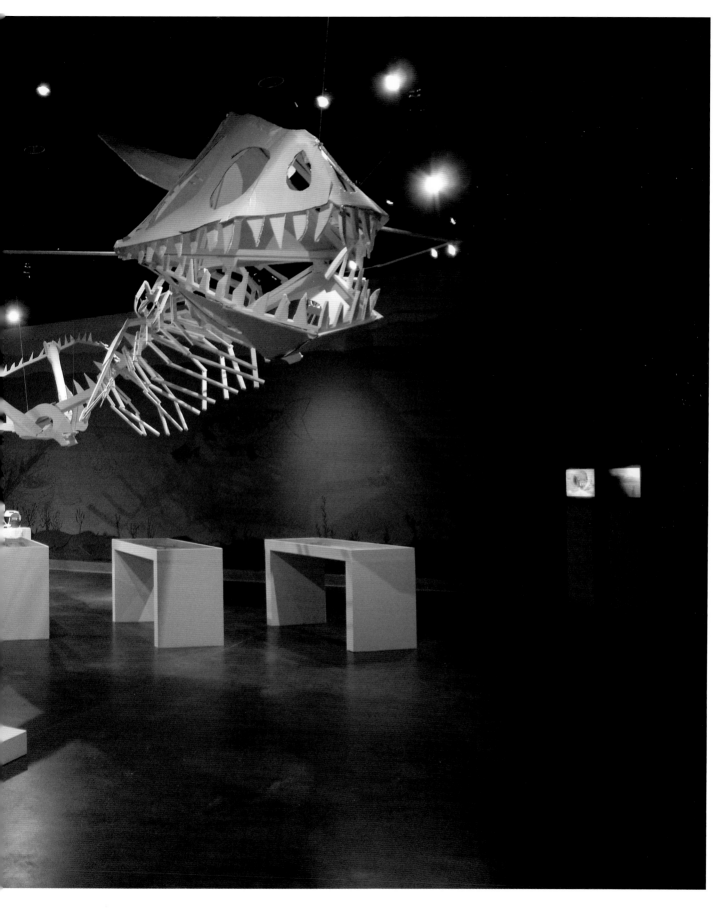

[pages 100–103]
Corner Store (details) 2009
Mixed media installation, dimensions variable
Courtesy of the artists

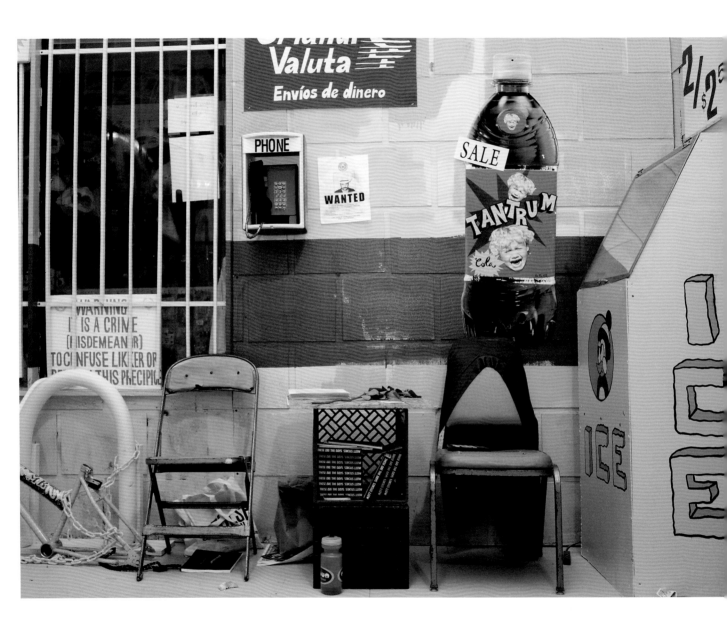

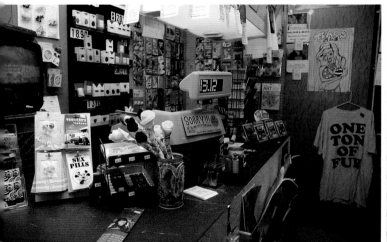

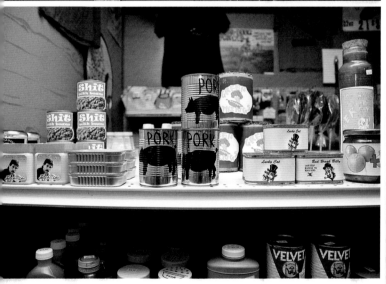

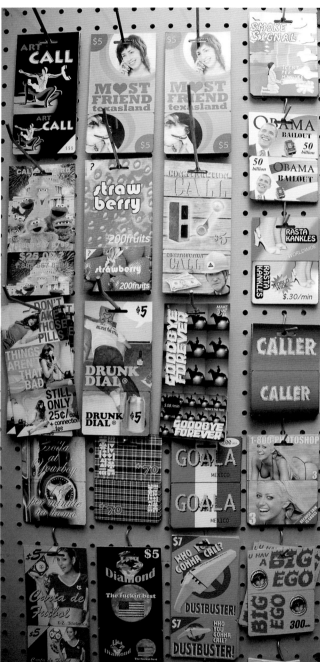

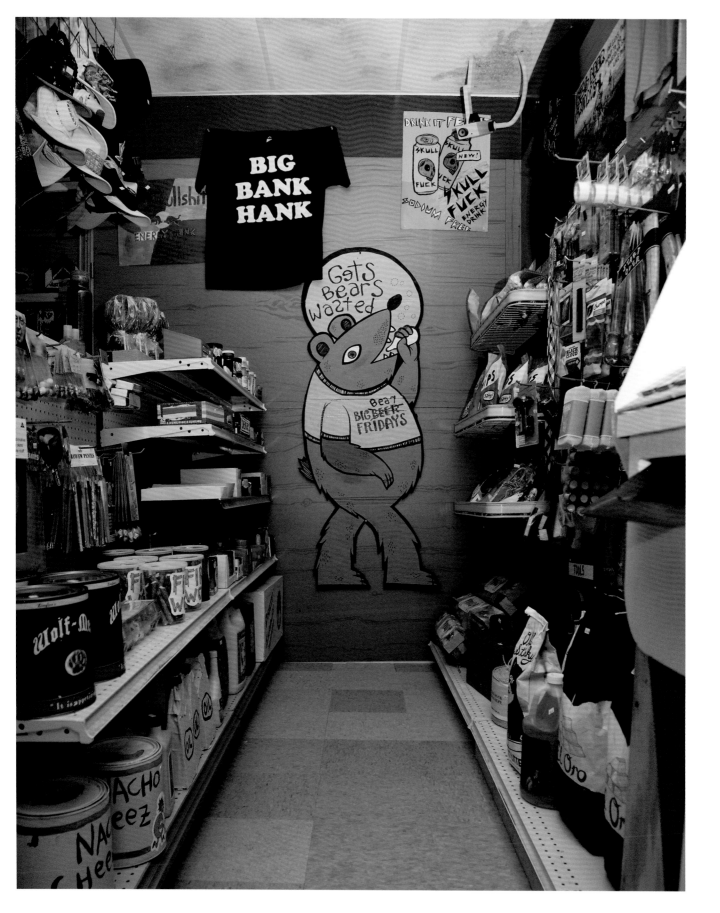

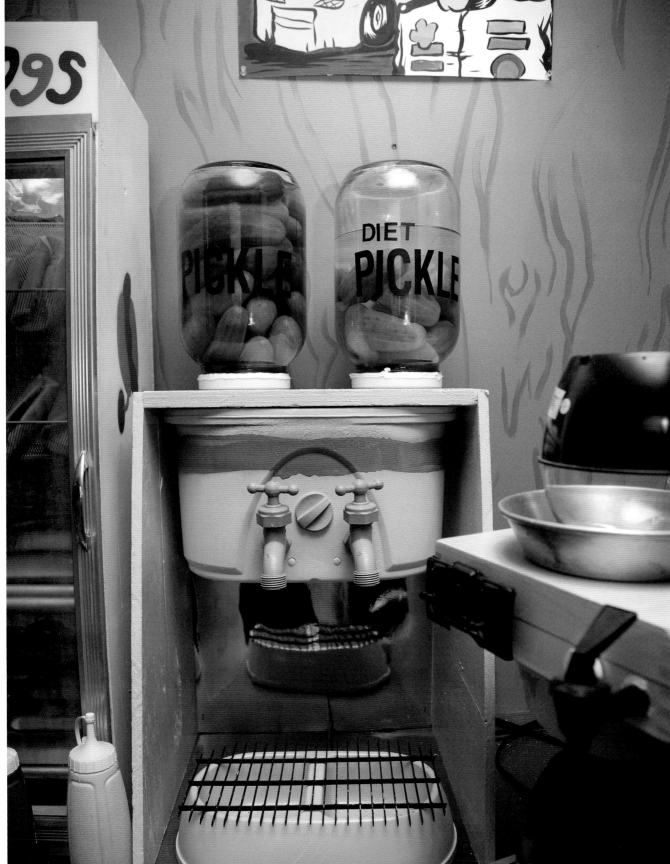

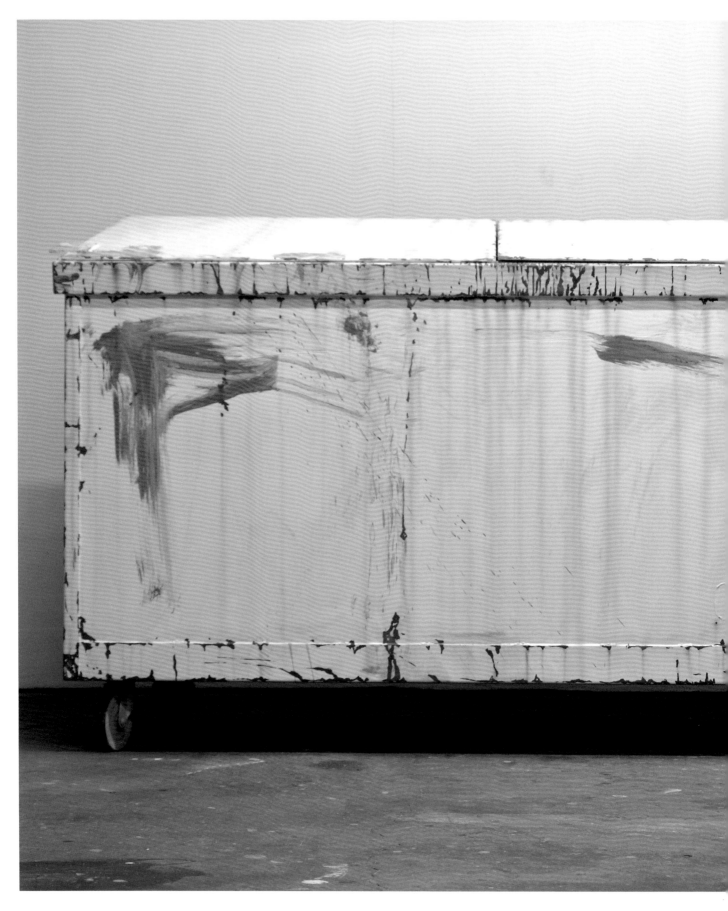

On first encounter, **KAZ OSHIRO**'s sculptures appear deceptively authentic, as if the artist merely filled a gallery with streamlined kitchen cabinets, side-by-side washer/dryer combinations, microwave ovens, or guitar amplifiers. Closer inspection reveals clear indications of wear and tear or that things are outdated. Soon evidence appears that the artist has imposed some more significant transformation on these objects: details are omitted; graphic stickers, unidentified stains, or haphazard spills personalize the objects. Finally, by viewing the objects from all sides, one often discovers that their backs are absent, revealing their interiors as well as the materials and process used to fabricate the nonfunctional works.

Particular to Oshiro's sculpture is his use of the traditional art materials of acrylic paint, canvas, and stretcher bars. Rather than using these materials to depict things in a two-dimensional, illusionistic way, Oshiro constructs three-dimensional interpretations of these familiar objects. In some sense, his sculptures are three-dimensional paintings, whether on the wall or freestanding, entering the viewer's space.

Art historical references abound in the work, particularly references to Pop art and Minimalism. The generic, common-place subjects recall those preferred by Pop artists like Claes Oldenburg, James Rosenquist, and Andy Warhol. Strict geometric forms, serial components, and a general lack of individualism connect to minimalists Carl Andre and Donald Judd. On a different note, Oshiro's careful and meticulous fabrication emphasizes these sculptures' hyperrealist attributes and association with trompe l'oeil paintings. Their pristine surfaces link them to the work of fellow California artists such as Larry Bell and John McCracken, associated with the Finish Fetish movement. Oshiro acknowledges this blending of sources: "I hope to create Post-Pop Art [painting] that juxtaposes Pop and Minimalism with the flavor of Neo-Geo, appropriation, and Photorealism,

and present them as a still-life of my generation."[1]

Kaz Oshiro's hyperreal sculptures deceive viewers before they reveal clues about what they actually are—painted canvases structured in familiar shapes that ultimately resemble three-dimensional things from the real world.

Kaz Oshiro was born in Okinawa, Japan, in 1967, and came to California in the late 1980s. Oshiro studied at California State University in Los Angeles, earning both a Bachelor of Arts in 1998 and a Master of Fine Arts in 2002. Oshiro is based in Los Angeles, and his sculpture has been widely exhibited over the past decade.

1 Kaz Oshiro quoted in Mitchell Algus, "Mitchell Algus on John Dogg and Kaz Oshiro," *2003 Summer Program*, *apexart*. http://www.apexart.org/images/siegel/ 2003%20Summer.pdf (accessed June 28, 2010).

[page 104]
Disposal Bin (White with Orange Swoosh) (detail)
2009
Acrylic on stretched canvas over panel and caster wheels,
47½ × 75 × 34¼ in.
Courtesy of the artist and Yvon Lambert New York,
New York

Disposal Bin (White with Orange Swoosh) 2009
Acrylic on stretched canvas over panel and caster wheels,
47½ × 75 × 34¼ in.
Courtesy of the artist and Yvon Lambert New York,
New York

Poster photograph for **Driving with Dementia: Kaz Oshiro and Dan Douke**, Rosamund Felsen Gallery, Santa Monica, California, 2009

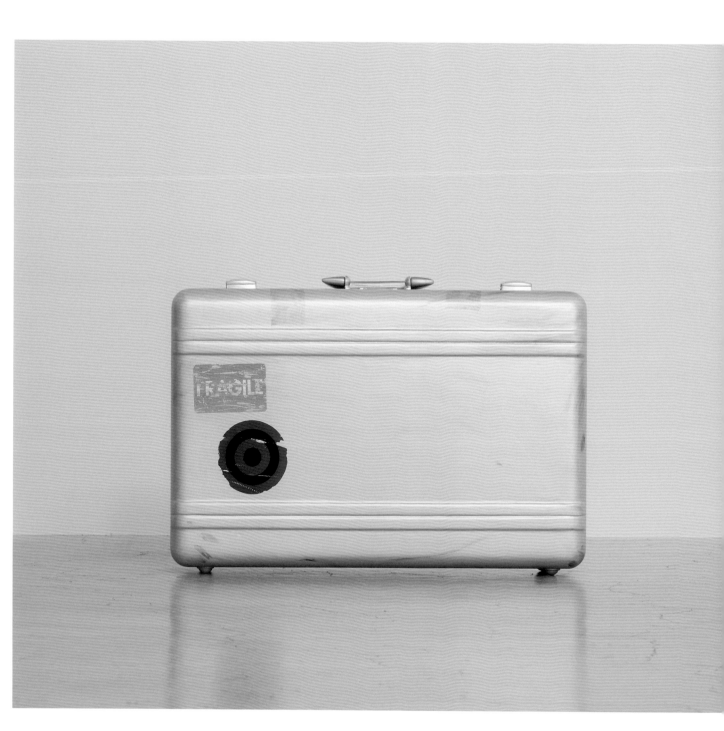

Trash Bin #15 (Cigarette Burns) 2008
Acrylic on stretched canvas, 39¾ × 20⅛ × 20⅛ in.
Courtesy of the artist

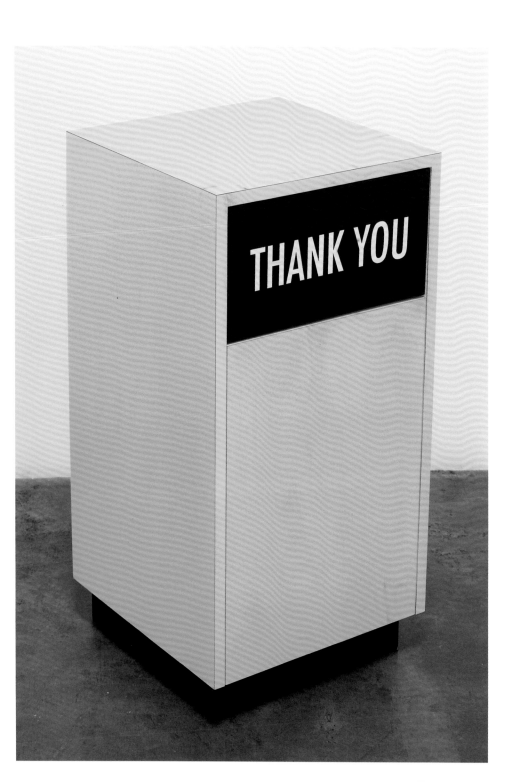

Untitled Corner Piece (Turquoise) 2008
Acrylic on stretched canvas, left section 30⅜ × 32⅛ × 9¼ in.,
right section 30⅜ × 62 × 9¼ in.
Courtesy of the artist

Installation view, **False Gestures**, Rosamund Felsen
Gallery, Santa Monica, California, 2009

Untitled Shelf (orange) 2008
Acrylic on stretched canvas, 22¾ × 66⅞ × 15⅝ in.
Courtesy of the artist

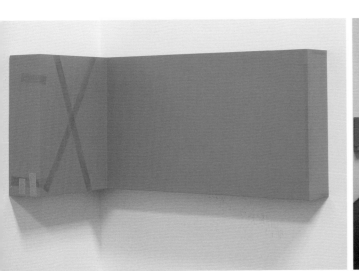

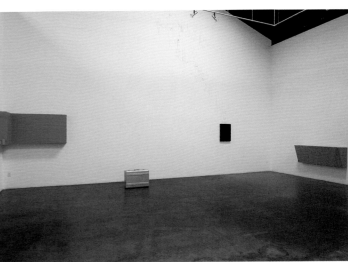

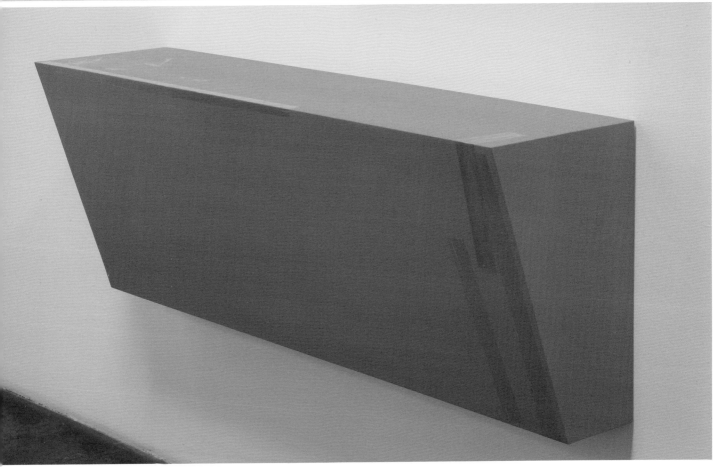

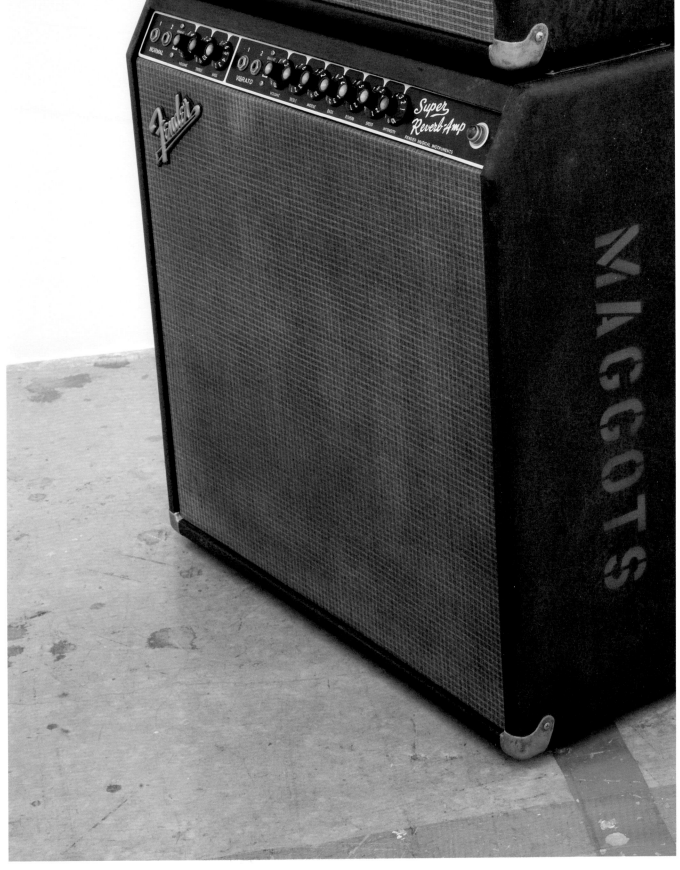

The natural world and the built environment coexist in the art of **MARK SCHATZ**. Earth's raw and unblemished topography, stacked and intersecting interstate highway systems, and old luggage well worn from travel are among the subjects transformed into works of art in Schatz's hands. The artist's creations transcend these mundane sources by juxtaposing traditional art supplies with common building materials, shifting scale and perspective, while using symbolism and metaphor to communicate underlying concepts.

In his *Personal Baggage* series, Schatz roughly carved luggage and moving boxes from blocks created by bonding together scraps of foam and gypsum. Familiar, finished forms reveal strata of the compressed material from which they are carved, recalling geological layers of earth or rock. Thus, the manufactured sculptures of the luggage contain visual references to natural forms. Other works by Schatz similarly integrate natural imagery with industrial materials: a patchwork of gridded farmland or the undulating path of a river fashioned from layers of cheap corrugated cardboard.

In a complementary manner, Schatz finely crafts sculptures employing materials, tools, approaches, and techniques associated with model making. He attaches detailed, miniature re-creations of verdant landscapes dotted with human-made storage towers to the underside of what appear to be chunks of earth suspended in midair. Dense clusters of minute International style buildings resemble a Google Earth map that Schatz presents in three dimensions.

Throughout the work of Mark Schatz, subjects from nature reside alongside those made by humans. For some, these combinations appear unsympathetic and irreconcilable. For Schatz, they are in great harmony: "Nature and culture may seem at odds more often than not, but I've begun to wonder if they're not two sides of the same coin."[1]

Mark Schatz was born in Denver, Colorado, in 1975, and grew up in and around Ann Arbor, Michigan. He studied sculpture at the University of Michigan, Ann Arbor, where he earned a Bachelor of Fine Arts in 1998. After relocating to Texas, Schatz received a Master of Fine Arts from the University of Texas at Austin in 2005. That same year he moved with his family to New Orleans, only to flee the devastation of Hurricane Katrina shortly after his arrival. Travel, movement, location, relocation, space, and the sense of place—these themes pervade the artist's life as well as inspire his art.

1 Mark Schatz, e-mail message to Lana Shafer, Semmes Foundation Intern in Museum Studies, April 7, 2010.

[page 112]
Accumulation Study #1 (detail) 2008
Polymerized gypsum, gouache, and colored pencil, 7 × 7 × 4 in.
Courtesy of the artist

Googling Mackinac 2007
Collected cardboard, wood, styrene, and model foliage, 8 × 36 × 180 in., with suspended elements at various heights
Courtesy of the artist

The View From Here (details) 2009
Cardboard moving and storage boxes, and scrap wood,
144 × 144 × 240 in.
Courtesy of the artist

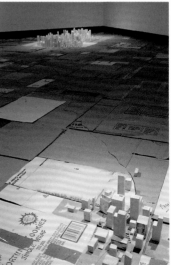

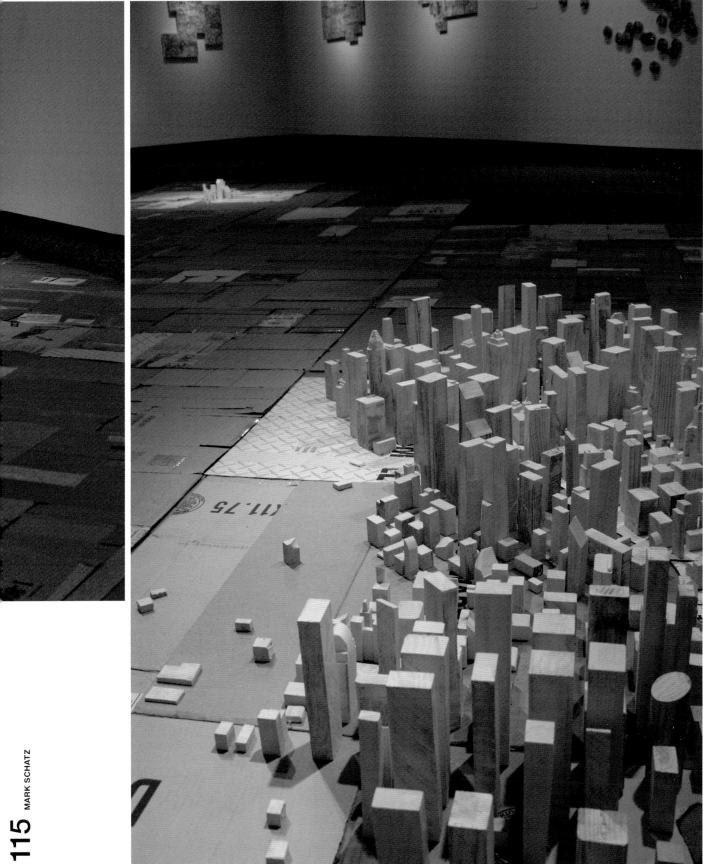

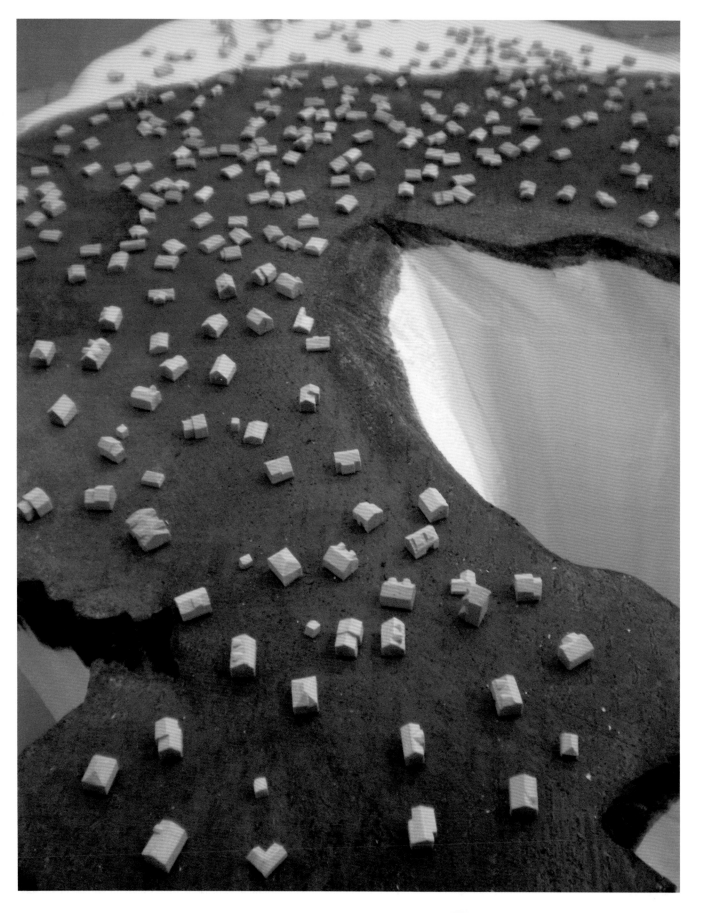

A Map Drawn from Memory, Torn to Pieces, and Thrown into the Sea (in process) (detail) 2009
EPS foam, wood, plaster, paints, and model foliage,
144 × 120 × 96 in.
Courtesy of the artist

[clockwise from top left]
Googling Mackinac (detail) 2007
Collected cardboard, wood, styrene, and model foliage,
8 × 36 × 180 in., with suspended elements at
various heights
Courtesy of the artist

A Map Drawn from Memory, Torn to Pieces, and Thrown into the Sea (detail) 2009
EPS foam, wood, plaster, paints, and model foliage,
144 × 120 × 96 in.
Courtesy of the artist

Untitled Study (detail) 2009
Cardboard moving and storage boxes, 36 × 72 × 3½ in.
Courtesy of the artist

A Map Drawn from Memory, Torn to Pieces, and Thrown into the Sea (detail) 2009
EPS foam, wood, plaster, paints, and model foliage,
144 × 120 × 96 in.
Courtesy of the artist

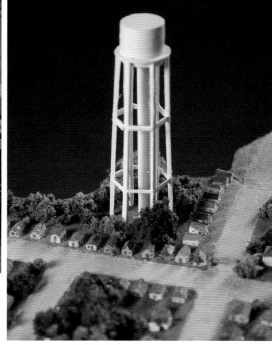

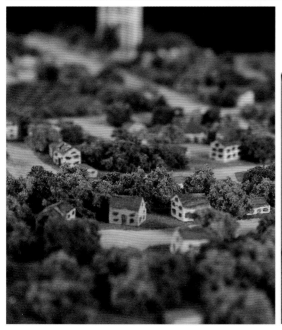

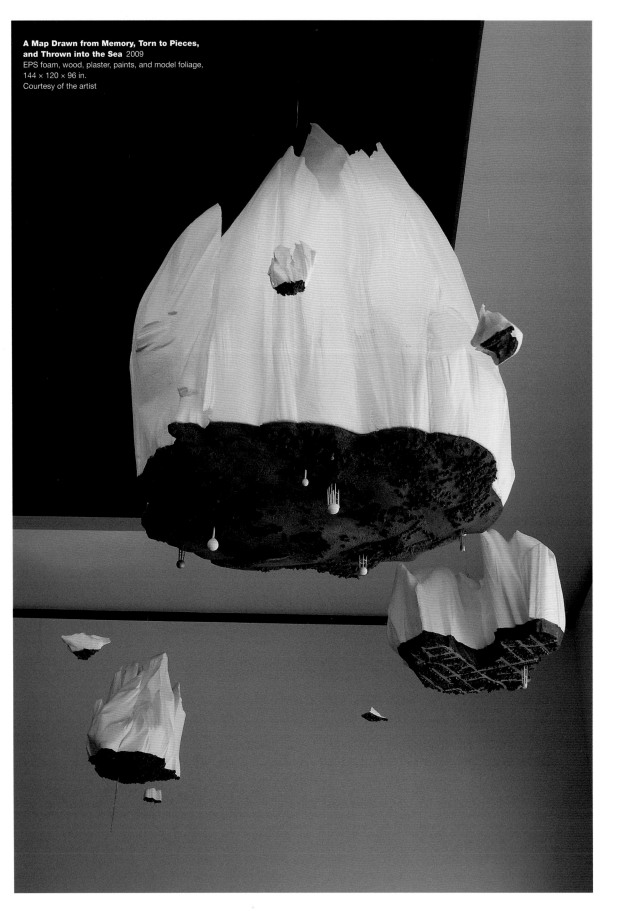

A Map Drawn from Memory, Torn to Pieces,
and Thrown into the Sea 2009
EPS foam, wood, plaster, paints, and model foliage,
144 × 120 × 96 in.
Courtesy of the artist

Sediment #1 (CP&LH) 2008
Polystyrene, urethane, and amber shellac, 11 × 11 × 14 in.
Courtesy of the artist

Sediment #2 (CP&LH) 2008
Polystyrene, urethane, and amber shellac, 12½ × 11 × 9 in.
Courtesy of the artist

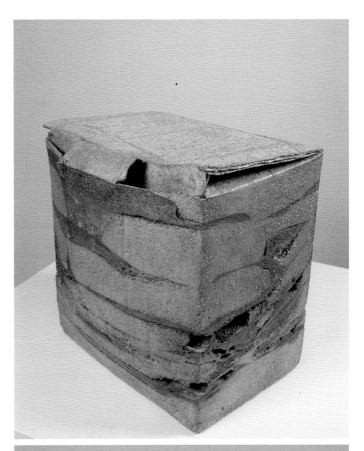

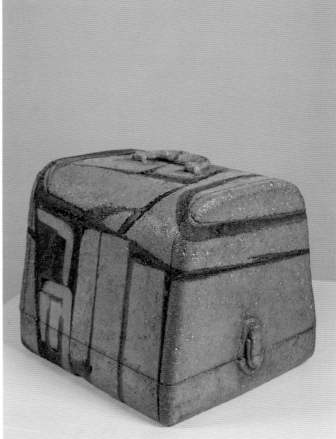

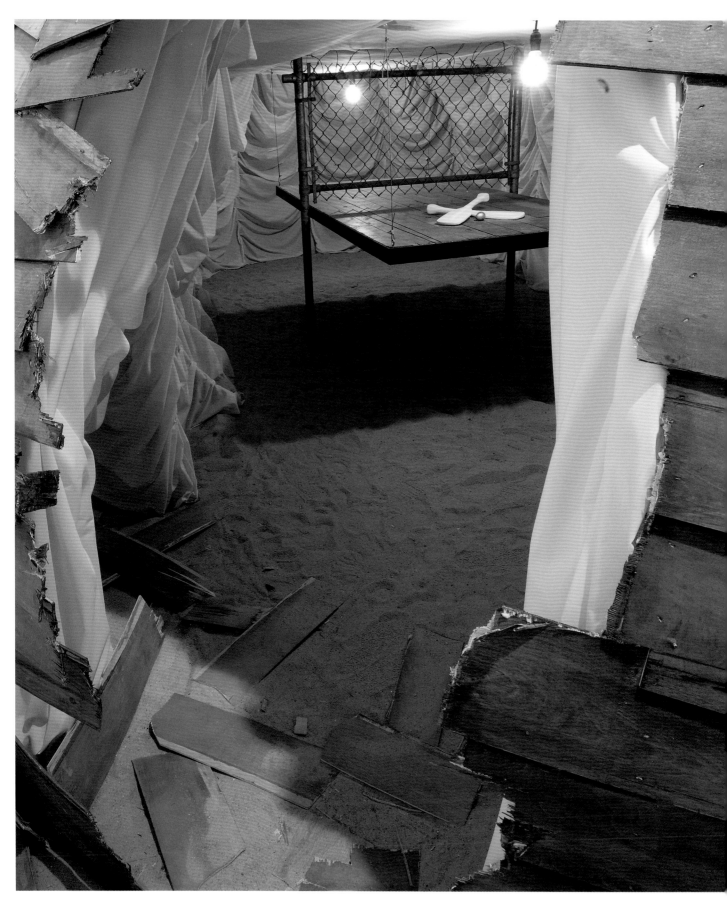

JADE TOWNSEND's

highly theatrical sculptures and installations use familiar imagery to explore themes of displacement, allegory, and alchemy. With subjects drawn from history, literature, popular culture, and everyday life, Townsend's works integrate many types of materials in a diverse range of forms. While varied in appearance, his art is interconnected through its underlying themes, use of recurring visual motifs, combination of found and fabricated elements, and overall dramatic sensibility. Initially a painter of abstract compositions, Townsend turned to making three-dimensional work to better explore complex concepts.

Townsend's 2008 installation *YARDSALE* is a three-dimensional comment on the American Dream. The contents of a typical home are turned upside down, as if a storm recently ripped through the interior space. A toppled dining table smashed one of the dining chairs in its fall; the upright piano's keyboard became an elegant ripple; lampshades sit askew on their bases; papers are strewn across the floor. Although filled with familiar trappings of domesticity, *YARDSALE* employs generic, stylized furniture and accessories in overall monochromatic white to enhance the disquieting effects and create a sense of distance from the viewer. An open door on one of the walls leads to a dark, ominous space beyond the installation's interior, where the outdoors and nature barely exist. In Townsend's words, *YARDSALE* and his related works are "concerned with symbolic imagery relating to the feelings of apathetic comfort, the marginalized idea of rebellion, and recently, the allegorical relationship between alchemy and the American dream."[1]

The human figure is often present in Townsend's art, either as a character acting out the artist's narratives, or as an implied presence, not actually seen but sensed. In *Born Between Piss and Shit*, 2007, life-size fabricated figures pull open a frame house from opposite sides. Similarly, *long division*, 2009, includes a fully clothed skeleton. In contrast, no human is present in *YARDSALE*, except for the viewer entering the installation.

Regardless of their final form, Jade Townsend's sculptures and installations use theatrical techniques to engage an audience. Once in his control, viewers see a darker, anarchistic view of the world.

Jade Townsend was born in 1977 in Des Moines, Iowa. He studied painting at Iowa State University in Ames, earning a Bachelor of Fine Arts in 1999. The following year he moved to New York, where he began making sculpture and installation works. In 2003, Townsend received a Master of Fine Arts from Hunter College of the City University of New York. He currently lives and works in Brooklyn, New York.

1 "Artists: Jade Townsend: Statement," Priska C. Juschka Fine Art, http://www.priskajuschkafineart .com/artists/Jade_Townsend/statement.php (accessed June 30, 2010).

[page 120]
Sick, Sick Wind (detail) 2009
Sand, lauan, stain, Krylon chrome spray paint, rope, t-shirts, pine, AC plywood, brass, light bulbs, fabric, chainlink fence, barbed wire, and polystyrene foam, 360 × 360 × 126 in.
Courtesy of the artist and Priska C. Juschka Fine Art, New York, New York

Sketch for YARDSALE 2008
Courtesy of the artist and Priska C. Juschka Fine Art, New York, New York

Study for BETWEEN HERE AND THERE 2010
Oil, ink, and graphite on paper, 18 × 29 in.
Courtesy of the artist and Priska C. Juschka Fine Art, New York, New York

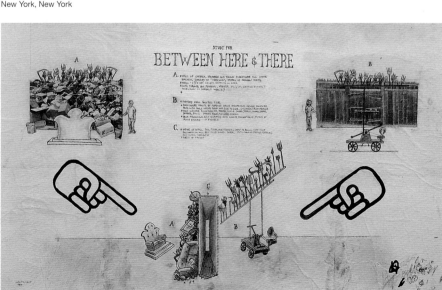

Sick, Sick Wind 2009
Sand, lauan, stain, Krylon chrome spray paint, rope,
t-shirts, pine, AC plywood, brass, light bulbs, fabric,
chainlink fence, barbed wire, and polystyrene foam,
360 × 360 × 126 in.
Courtesy of the artist and Priska C. Juschka Fine Art,
New York, New York

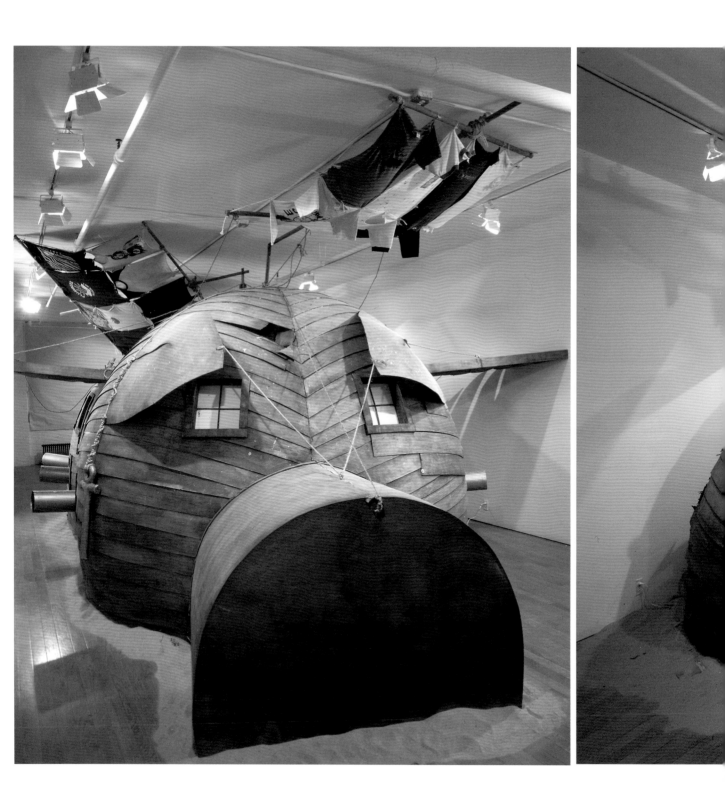

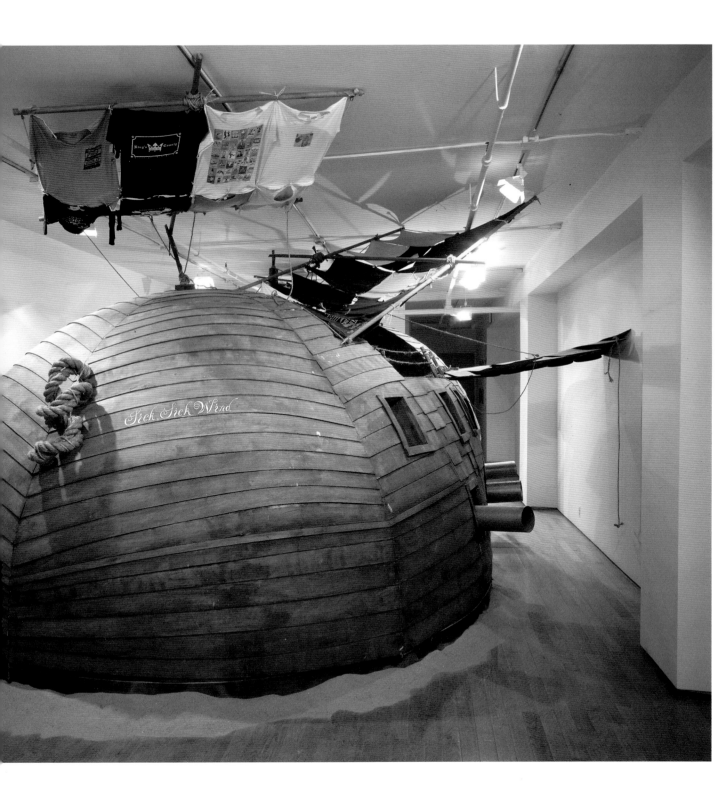

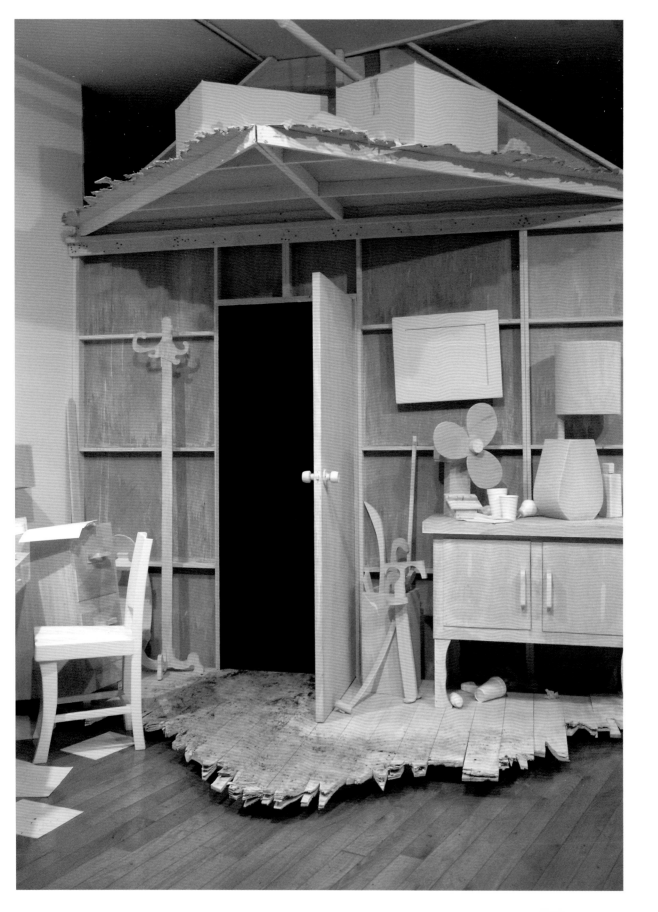

YARDSALE 2008
Mixed media installation, dimensions variable
Courtesy of the artist and Priska C. Juschka Fine Art,
New York, New York

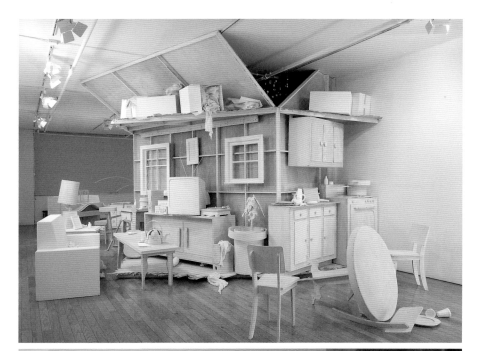

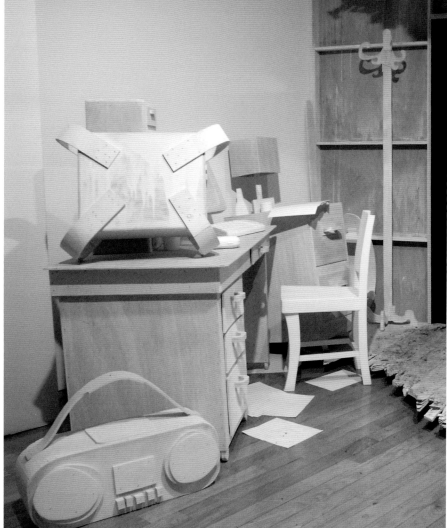

The Bellman 2009
Polystyrene foam, lauan, pine armature, fabric, stain,
Krylon chrome spray paint, sand, and various stuffing,
55 × 50 × 80 in.
Courtesy of the artist and Priska C. Juschka Fine Art,
New York, New York

[below]
**Of Alchemy, Dreams, and Revolution; Ticking Like
a Fucking Bomb** 2007
Brick, gold Krylon, lauan, wiggle board, Ultralite, black
bandanas, balsa foam, white latex primer, flat white Krylon,
and paint marker, 16 × 11 × 18 in.
Courtesy of the artist and Priska C. Juschka Fine Art,
New York, New York

Born Between Piss & Shit (detail) 2007
Lauan, AC plywood, white acrylic paint, polystyrene foam,
glow-in-the-dark stars, rope, pine armatures, various
stuffing, clothing, wigs, found window, and broken glass,
dimensions variable
Courtesy of the artist and Priska C. Juschka Fine Art,
New York, New York

...and the days fly by on their own (exterior and
interior details) 2006
Mixed media installation, dimensions variable
Courtesy of the artist and Priska C. Juschka Fine Art,
New York, New York

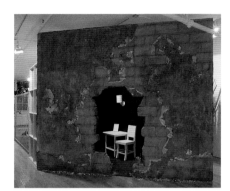

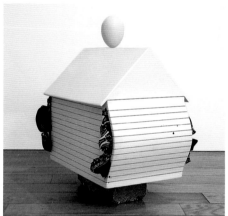

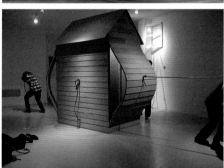

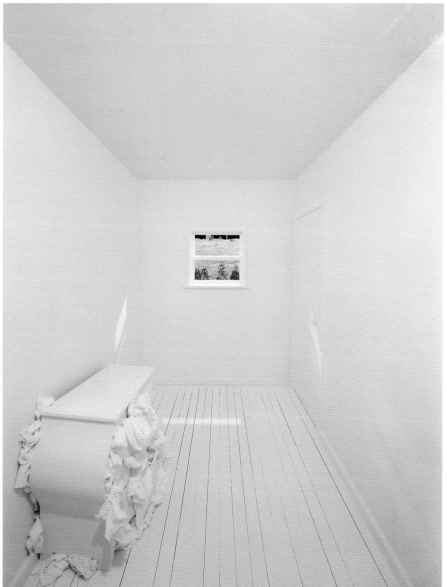

Photography Credits
Pages 1, 2 (bottom right), 7, 12, 40, 42–47:
Jeffery Sturges
Page 21 (figure A): Erich Lessing/Art Resource,
NY
Page 21 (figure B): Philippe Migeat/CNAC/
MNAM/Dist. Réunion des Musées Nationaux/Art
Resource, NY
Page 21 (figure E): Digital Image © The Museum
of Modern Art/Licensed by SCALA/Art Resource,
NY
Pages 22–23, 120–127: Priska C. Juschka
Fine Art, New York, New York
Page 41 (bottom): Kim Keever
Page 50: Heriberto Ibarra
Page 51: Shaune Kolber
Pages 52, 53, 54 (top): Hermann Feldhaus
Pages 60, 61: Orcutt & Van Putten
Page 62: Tom Hanson
Pages 88, 92, 94: Grant Mudford, courtesy of
Rosamund Felsen Gallery, Santa Monica,
California
Pages 89 (top), 90 (bottom right), 91 (bottom
right): Courtesy of McKenzie Fine Art Inc.,
New York, New York
Page 89 (bottom): Patrick Boemer
Pages 90 (top left, top right), 91 (top left, top
right, bottom left), 95: Roy Porello, courtesy of
Quint Contemporary Art, La Jolla, California
Pages 93, 105 (bottom), 108, 109: Grant Mudford
Pages 106, 107: Takumi Ota

New Image Sculpture is published on the
occasion of an exhibition of the same title,
presented at the McNay Art Museum, San
Antonio, Texas, February 16–May 8, 2011.
This exhibition was organized by the McNay
Art Museum. Funding is provided by the Flora
Crichton Visiting Artist Fund, The Ewing Halsell
Foundation Endowment for Visiting Artists, the
King Ranch Family Trust Endowment for Vis-
iting Artists, the Nathalie and Gladys Dalkowitz
Charitable Trust, and the Director's Circle.

Library of Congress Cataloging-in-Publication
Data
Barilleaux, René Paul.
 New image sculpture / René Paul Barilleaux,
Eleanor Heartney.
 p. cm.
 Issued in connection with an exhibition held
February 16–May 8, 2011, McNay Art Museum,
San Antonio, Texas.
 ISBN 978-0-916677-55-8 (alk. paper)
 1. Sculpture, American—21st century—
Themes, motives—Exhibitions. I. Heartney,
Eleanor, 1954– II. McNay Art Museum. III. Title.
NB202.6B37 2011
730.973'074764351—dc22 2010043957

Produced by Marquand Books, Inc., Seattle
 www.marquand.com

Copyedited and proofread by Rose M. Glennon.
Designed by Jeff Wincapaw.
Typeset in Helvetica Neue by Susen E. Kelly.
Printed and bound in China by Artron Color
Printing Co., Ltd.

theMcNay